A NEIGHBORHOOD guide to WASHINGTON, D.C.'S HIDDEN HISTORY

JEANNE FOGLE

THE
History
PRESS

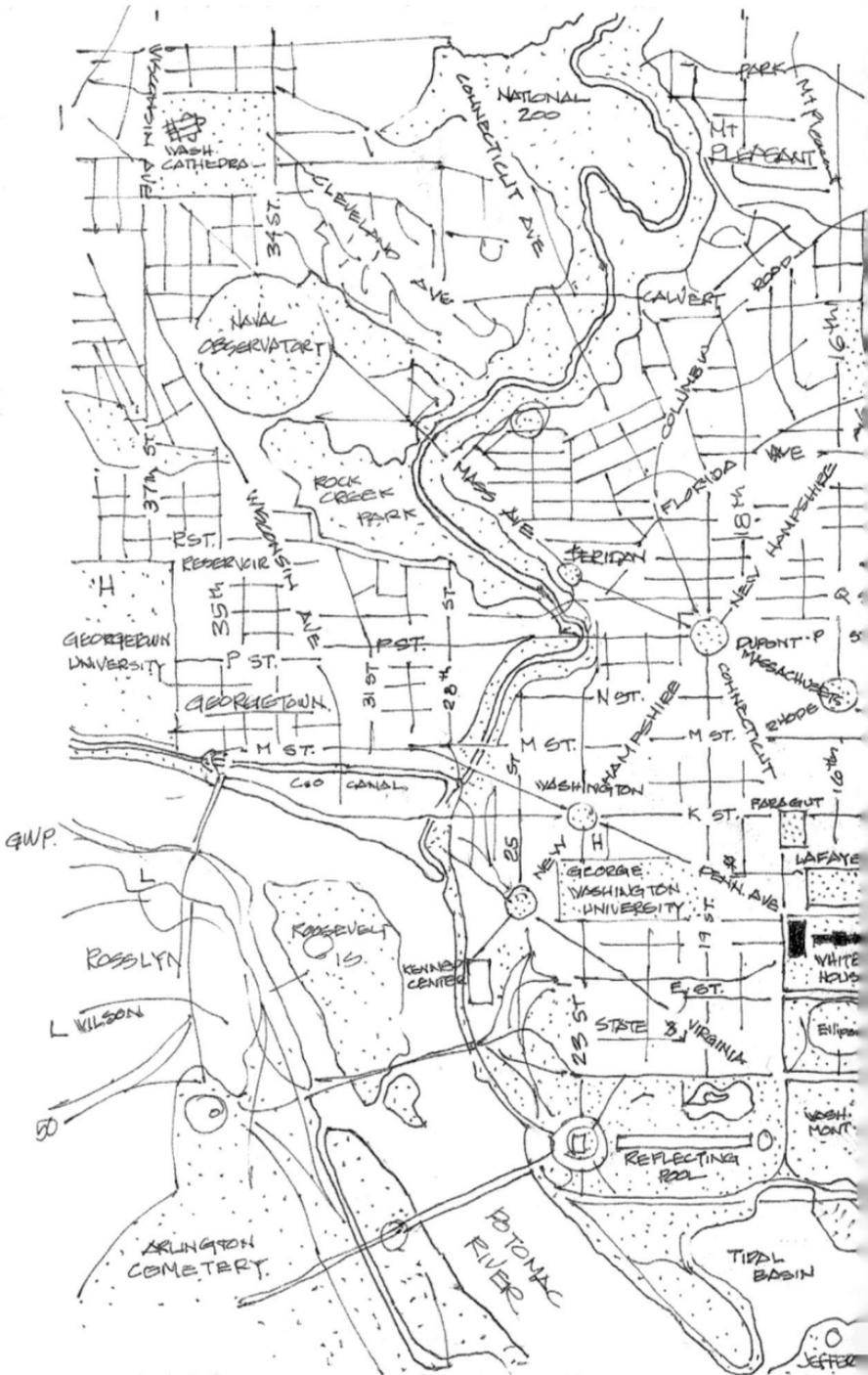

Washington, D.C. city map. *By Edward F. Fogle.*

Published by The History Press
Charleston, SC 29403
www.historypress.net

Copyright © 2009 by Jeanne Fogle
All rights reserved

Cover design by Natasha Momberger

First published 2009
Second printing 2010
Third printing 2013

ISBN 9781540219763

Library of Congress Cataloging-in-Publication Data

Fogle, Jeanne.
A neighborhood guide to Washington, D.C.'s hidden history / Jeanne Fogle.
p. cm.
Includes bibliographical references.
ISBN 9781540219763
1. Washington (D.C.)--Description and travel. 2. Washington (D.C.)--Buildings,
structures, etc. 3. Historic sites--Washington (D.C.) 4. Historic buildings--
Washington (D.C.) 5. Washington (D.C.)--History. I. Title.
F195.F587 2009
917.5304'42--dc22
2009010456

Contents

CONTENTS

Contents

Contents

Introduction

B eyond the memorials, museums and monumental buildings in Washington are historic neighborhoods filled with hidden treasures and enchanting stories of the past. Rich, poor, noble, humble, famous and infamous people from around the world have all come to Washington during the past 220 years. Some stayed longer than others, but many left legacies that can be found in the neighborhoods, reflected in the small museums, outdoor sculpture and the variety of religious structures poised next to historic mansions, brick row houses or tiny wood-frame dwellings. Washington's neighborhoods are unique and diverse, reflecting a remarkable past.

Washington developed slowly as a residential city. In 1800, when the federal government began to occupy the new capital city, many government workers had no other option but to reside in local taverns. Laborers lived in sheds or makeshift lodges. Because the city was built on farmland, farmers still resided within sight of the federal buildings, and their animals roamed freely through the unpaved streets. Members of Congress were hesitant to commit time, effort or money to transform the nation's capital into a livable city. Their tenure here was temporary and they never considered Washington their home.

Near LAFAYETTE SQUARE and the White House, however, wealthy and influential people began building homes, like the Octagon House (chapter 1, site 4). St. John's Church (chapter 1, site 5),

Row houses in Washington, D.C. *By Edward F. Fogle.*

known as the "Church of the Presidents," was built in 1816 and brought a sense of community to this exclusive neighborhood. Many early church members shared an interest in the business of the emerging city and an optimistic belief in the new experiment of self-government. They chose to live near the president because proximity to power is power.

Several large boardinghouses were quickly constructed on CAPITOL HILL to accommodate the members of Congress. Soon, rows of small frame and brick houses were erected nearby for the Navy Yard workers. The Marine Barracks and the commandant's house were built near the Anacostia River waterfront. The neighborhood near the Capitol began to flourish. Churches were organized, charities and civic associations were created, a market house was built, a cemetery was established and several fine brick dwellings, like the Sewall-Belmont House (chapter 2, site 2), were constructed by the wealthier residents.

The port city of GEORGETOWN on the Potomac River was well established when Congress arrived in 1800. Older than Washington by nearly one hundred years, Georgetown boasted many country estates, like Dumbarton House (chapter 3, site 3), and grand mansions built by successful merchants and gentleman farmers. However, Georgetown was four miles away from the Capitol, and few new residents working for the government could afford the horse and carriage that were necessary for the commute.

People lived where they worked, and this tradition continued into the twentieth century when the old downtown area evolved into Washington's CHINATOWN. The Treasury Building and the Old Patent Office (chapter 4, site 1), which were built seven blocks apart, anchored the neighborhood between the White House and the Capitol. By the 1860s, this was a German neighborhood, with hardworking residents who ran the many businesses and attended the German churches and synagogues like Old Adas Israel (chapter 4, site 8).

The nouveaux riches of the late nineteenth century came to Washington in order to build their winter homes near DUPONT CIRCLE. This neighborhood was newly established near the outer northwest boundary of the old city. Dupont Circle became

the new center of society, replacing both old Georgetown and Lafayette Square. Soon, the new neighborhood of KALORAMA (which means "beautiful view" in Greek) was created north of Dupont Circle. Only large homes or luxury apartment buildings were built in this exclusive area. Five presidents, including Woodrow Wilson (chapter 5, site 3), have owned homes in Kalorama. Many of the grand old mansions have become embassies; others have been converted into private clubs, art galleries and museums.

The FOGGY BOTTOM neighborhood, located between the White House and Georgetown, supported Washington's light industry throughout the nineteenth century. Modest, two-story, wood or brick row houses were built for the workers. In 1910, the George Washington University relocated to Foggy Bottom and row houses became classrooms. Whole blocks of houses were replaced by government buildings and white marble Beaux Arts structures like the American Red Cross (chapter 6, site 4). The few houses that were saved in the charming old neighborhood have become hidden treasures among the 1960s Modernist structures.

Washington's first suburb was established after the Civil War on a high hill called MT. PLEASANT. A few wealthy residents built grand homes and encouraged the construction of fine embassies (chapter 7, site 4) and national churches. Streetcar lines were built and brought more people to Mt. Pleasant, nearby MERIDIAN HILL and Lanier Heights (later renamed ADAMS MORGAN). Substantial row houses and the city's first apartment buildings were built to accommodate the new residents. By the mid-twentieth century, however, the wealthy moved out and immigrants moved in, creating an international quarter that takes pride in its motto: "Unity in diversity."

MT. VERNON SQUARE is situated north of Washington's old downtown and south of an established African American neighborhood. Developed as a late nineteenth-century commercial and residential neighborhood, it was racially and economically mixed. A few blocks north, fine theatres, like the Lincoln Theatre (chapter 8, site 2), were located on the U STREET CORRIDOR, which was once called "Black Broadway." The popular nightclubs

attracted the great jazz performers like local-born Duke Ellington. The 1968 riots devastated the neighborhood, which was renamed SHAW. After forty years, revitalization has come to Shaw, and history and gentrification are mixed in the neighborhood now known as "the New U."

Toward the end of the nineteenth century, two suburbs-within-the-city, CLEVELAND PARK and WOODLEY PARK, were established on the heights above Georgetown, on what had previously been open fields and farmland. Several country estates were established in the area, including Rosedale (chapter 9, site 2), the Highlands, Tergaren and Woodley. The clean air and the cooler summer temperatures enticed people to create a summer community, and the most famous summer resident was President Cleveland. The area developed quickly, with charming architect-designed homes, grand apartment buildings and attractions like the National Cathedral, the Naval Observatory and the National Zoo (chapter 9, site 4).

Washington boasts more than fifty neighborhoods. Each is unique; each is significant for its parks, architectural styles and diverse residents. Some are more notable than others because of their age, location, historic sites or famous residents. Washington's neighborhoods are in a constant state of flux, changing to meet the needs of each new generation of residents who come to call Washington their home, for a few years or for a lifetime. Go beyond the monuments and discover what Washingtonians already know: that Washington is a city of great beauty, steeped in history and filled with some of the most interesting people in the world.

Chapter 1

Lafayette Square and the President's Neighborhood

Stories of love, scandal, diplomacy, tragedy and success fill every corner of the neighborhood surrounding the White House and Lafayette Square. For two hundred years, this has been the most important neighborhood in one of the most important cities in the world. Throughout its history, the country's wealthiest and most influential people have chosen to live or work in proximity to the White House, including high government officials, military heroes, diplomats, bankers, historians, philanthropists, socialites and men of independent means. Grand mansions, haughty hotels, prominent banks, important government buildings and renowned art museums have lined the streets and filled the blocks of this extraordinary historic neighborhood. The mixing of new and old architecture in this area is a reflection of the compromise of marrying politics, historic preservation and modern urban design.

For the first twenty years of Washington's existence, however, the president had no near neighbors. The White House fronted a park that had been the site of the Pierce family farm. Remnants of the former proprietor's past remained: an apple orchard, a deserted farmhouse, a tobacco barn and a fenced family graveyard. The area was also littered with mounds of broken stones, bricks and lumber, workmen's sheds, storehouses and brickyard kilns. The roads were unpaved, animals ran free and delusional vagabonds were in abundance. Great optimism

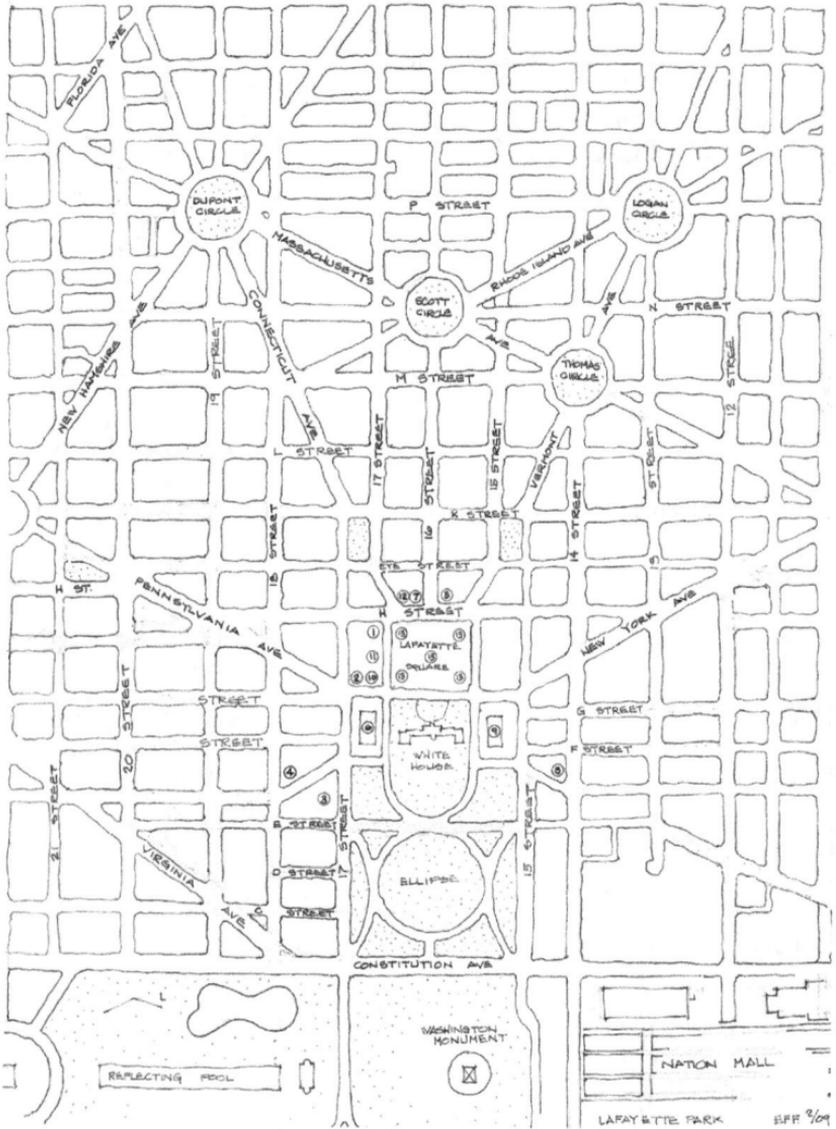

Map of Lafayette Square and the president's neighborhood. *By Edward F. Fogle.*

Lafayette Square and the President's Neighborhood

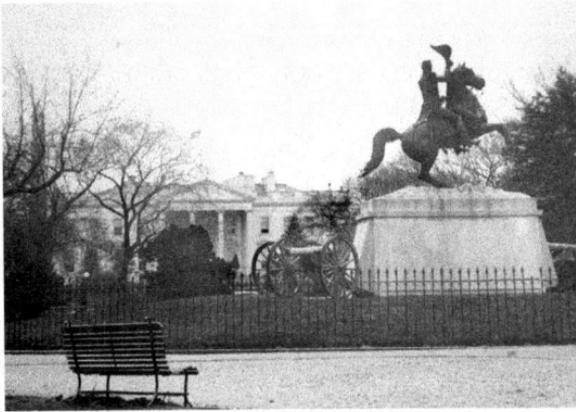

Lafayette Square and the White House. *Courtesy of the Washingtoniana Division, D.C. Public Library.*

often overshadowed reality in the president's neighborhood in the early nineteenth century. People, like Stephen Decatur (site 1), wanted to live near the president. Politicians and aristocrats arrived, although they could not bring their wives to Washington because suitable housing did not exist. Foreign ministers sent to Washington were mostly bachelors who considered Washington a hardship post; however, they added a unique dimension of sophistication that no other city in the country could claim.

By the mid-nineteenth century, the president's neighborhood was filling up with fine homes and fancy hotel-apartment buildings, like Willard's (site 8), which provided a setting for grand entertaining. The social season extended from January until Lent while Congress was in session. Women came to Washington and influenced society more than any other group. Generally, they were dependant on their husbands' wealth, so they made their reputations through their husbands' positions. A seemingly endless round of receptions and parties was hosted by competitive, ambitious wives, anxious to better their husbands' standing in society. In the latter part of the nineteenth century, the nouveaux riches of the industrial age invaded the neighborhood, creating a new society with excessive displays of wealth and ego. At the same time, scholars, scientists, inventors, artists, literary figures and explorers were attracted to Washington because of the Smithsonian Institution, the Library of Congress, the National

Geographic Society, the universities and the literary societies. These interesting individuals formed private clubs, many of which had their start in buildings near Lafayette Square.

With the advent of the twentieth century, the president's neighborhood became less residential and more oriented toward government (site 6) and associations. The old homes became offices and old buildings were replaced with new ones. The Beaux Arts style of classical architecture was embraced in Washington, and a profusion of stunning, temple-like marble buildings were constructed to house financial institutions, associations, galleries (site 3) and government offices. After two world wars and the Great Depression, the character of the president's neighborhood completely changed. The grand mansions were razed for parking lots that would later be replaced by mundane, Modernist office buildings. Then, in 1961, Jackie Kennedy drew attention to, and saved, the little houses that faced Lafayette Square. Historic designation was later given to many of the important remaining structures near the White House. The president's neighborhood, though devoid of neighbors, is now filled with memories of this nation's great history.

1. Decatur House
(748 Jackson Place, NW)

Commodore Stephen Decatur was the hero of the 1805 Tripolitan War, in which American warships defeated the Barbary Coast pirates who were extracting protection payments from several nations. Imbued with great social aspirations and with prize money awarded for his heroic deeds, Decatur moved to Washington with his charming wife, Susan. The couple carefully chose a conspicuous site on which to build their new home, designed by Benjamin Henry Latrobe. In 1818, Decatur's house became the first neighbor to the White House and the center of Washington society. The gaiety lasted less than two years. In 1820, Decatur was killed in a duel, challenged by his former mentor, Commodore James Barron, who felt that Decatur had

Decatur House. *By Edward F. Fogle.*

ruined his reputation. Susan Decatur, devastated at the death of her husband, moved to Georgetown, leasing Decatur House to diplomats, congressmen and vice presidents. In 1838, the wealthy hotelier John Gadsby purchased the house. Although his parties were the grandest in the city, he was often criticized for his involvement in the business of slave trading.

During the Civil War, the government took possession of Decatur House, which was later purchased by General Edward Beale and remodeled. Beale's son, Truxton, a career diplomat, and his wife, Marie, inherited the house and again it became the center of Washington society. After Truxton Beale died in the 1930s, Marie decided to bring attention to the historic nature of the house through her restoration efforts while she continued the tradition of entertaining. In 1952, she invited young Senator John Kennedy from Massachusetts to a black tie dinner party. When he arrived late, wearing a brown suit and red tie, Marie Beale greeted him with a good-natured scolding that he never forgot. In 1956, she bequeathed the house to the National Trust for Historic Preservation, thereby ensuring its survival by having it held "in Trust for the Nation."

2. Renwick Gallery
(Pennsylvania Avenue at 17th Street, NW)

Washington's first art gallery was "to be used solely for the purposes of encouraging American Genius." The gallery's benefactor was William Wilson Corcoran, Washington's greatest nineteenth-century philanthropist. Corcoran made his first fortune as a banker during the Mexican War. Through careful investments, his wealth multiplied. At the age of fifty-six, he decided to devote his full attention to personal affairs, philanthropies and collecting art. Corcoran preferred to support American artists at a time when only European artists were considered to have talent. His first major purchase was a sculpture by Hiram Powers entitled *The Greek Slave*, which he displayed in his home near the White House. Soon, however, the art collection outgrew the space. In 1859, Corcoran commissioned architect James Renwick to design an art gallery inspired by the new addition to the Louvre.

The Civil War began before the art could be installed into the new gallery, and the building was seized and occupied by the

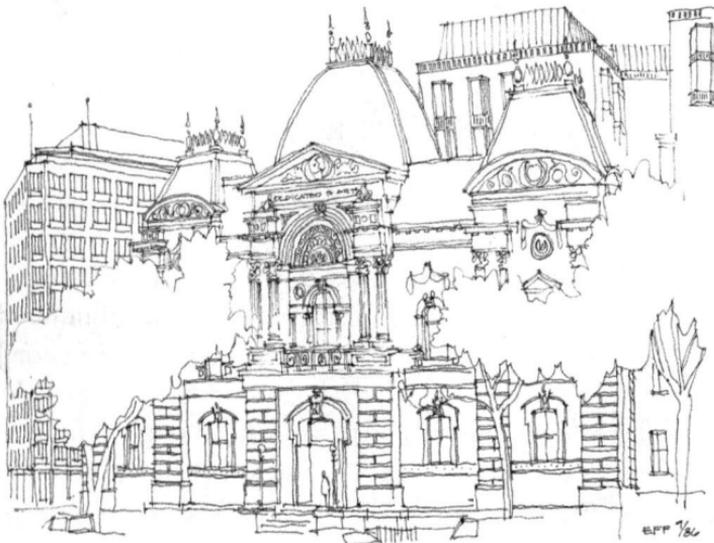

Renwick Gallery. *By Edward F. Fogle.*

government for nearly a decade. The badly damaged little gallery was eventually returned to Corcoran, who renovated it and opened it to the public in 1872. By 1897, the Corcoran collection was transferred to a new building. The U.S. Court of Claims occupied the old gallery until the 1960s, when it was declared an eyesore and firetrap. Jacqueline Kennedy worked diligently to save it, and in 1972 the gallery was restored, renamed to honor the architect and transferred to the Smithsonian American Art Museum. The Renwick Gallery's exhibitions feature the creative achievements of American designers and craftsmen. The phrase carved over the main entrance, "Dedicated to Art," proclaims the gallery's purpose and justly describes its founder.

3. Corcoran Gallery of Art
(17ᵀᴴ Street at New York Avenue, NW)

William Wilson Corcoran became a millionaire in the 1840s and decided to dedicate the rest of his life to judiciously giving his money away. He gave to the poor, to impoverished southern ladies and to universities, cemeteries and churches. Corcoran also gave a wonderful gift to the American people: a collection of American art that is considered to be the finest and most comprehensive assemblage of its kind. Corcoran built a gallery to display his art, and he stipulated that, at least two days a week, there should be no charge so that working-class people could enjoy what had previously been reserved for only the rich.

The first Corcoran Gallery of Art was built in 1858 near the White House. Forty years later a new gallery was built to accommodate the rapidly growing collection. A Beaux Arts–style, palatial marble building was designed that graciously wraps around a broad-angled corner. The new gallery earned the acclaim of Frank Lloyd Wright, who called it "the best designed building in Washington." W.W. Corcoran was one of the first art collectors to consider photography an art form and one of the first to support talented Americans. In the 1880s, he founded an art school that has been responsible for bringing recognition to many talented American artists, including Gene

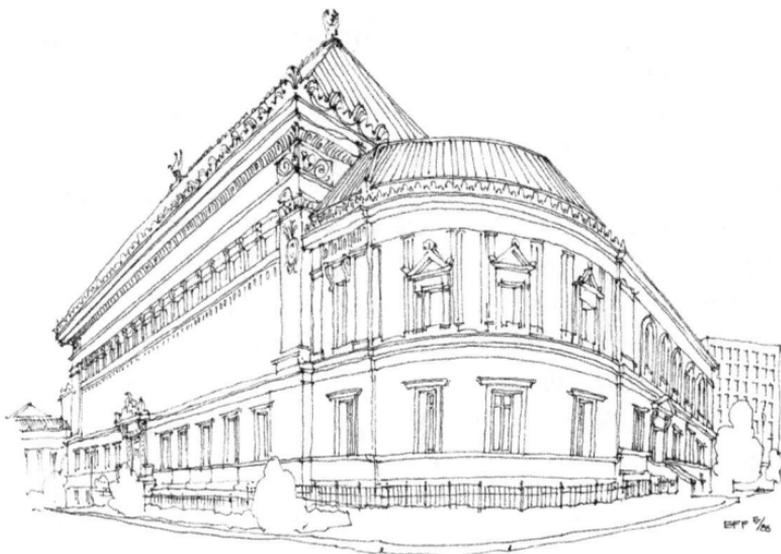

Corcoran Gallery of Art. *By Edward F. Fogle.*

Davis. The Corcoran Gallery of Art was created as an institution for "the perpetual establishment and encouragement of Painting, Sculpture, and the Fine Arts."

4. Octagon House
(18ᵀᴴ Street at New York Avenue, NW)

A twenty-nine-year-old wealthy Virginia planter named John Tayloe III built his new home near the White House in 1800. Dr. William Thornton, the architect of the Capitol, designed it, and the final cost was a shocking $35,000. The presence of this fabulous residence, however, served to affirm a belief in the future of the new capital city and inspired the construction of other grand mansions nearby. The Tayloe family played a major role in Washington's early social life. Their frequent entertainments were often allied with their business and political interests. In 1814, Octagon House became the first temporary presidential residence when John Tayloe offered it to President Madison after the White House was burned by the

British. The Treaty of Ghent, ending the War of 1812, was signed in the Octagon House's second-floor circular study.

Prior to the Civil War, various members of the Tayloe family occupied the home. When the neighborhood began to decline, the house was used as a school, for government offices and, finally, as a boardinghouse. By 1889 it was described as almost squalid. Glenn Brown, secretary of the American Institute of Architects (AIA), recognized that the poorly maintained home was "one of the best examples of work done in the year 1800"; he admired "its plan, character of design, workmanship, and location." In 1904, the house was purchased by the AIA, and the organization's members became early pioneers in the work of historic preservation. Never had a historic building been given so much attention by so many professionals. Octagon House became the AIA headquarters until 1970, when it was further restored and opened to the public as a museum.

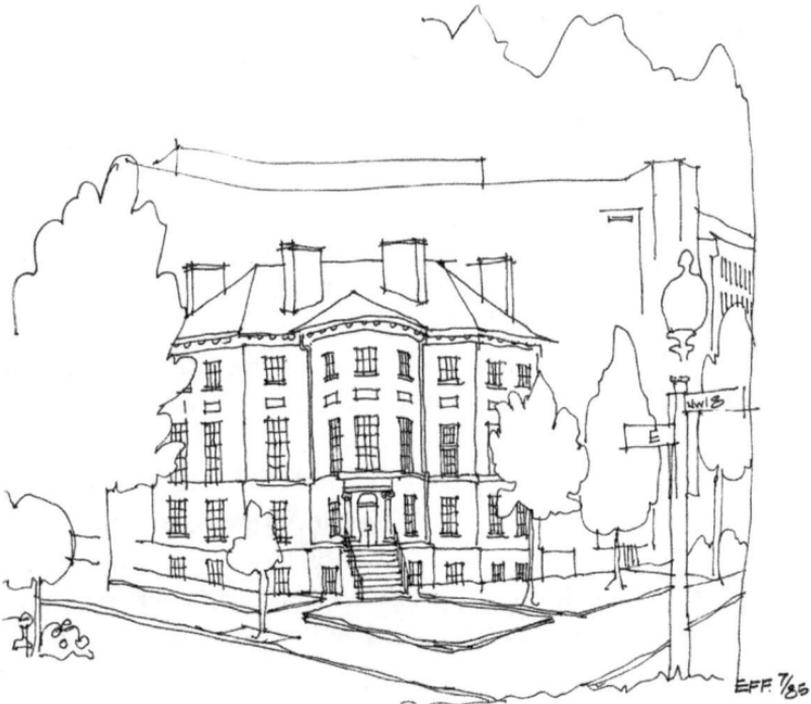

Octagon House. *By Edward F. Fogle.*

St. John's Church. *By Edward F. Fogle.*

5. ST. JOHN'S EPISCOPAL CHURCH
(16TH STREET AT H STREET, NW)

"I have just completed a church that made Washingtonians religious who had not been religious before," wrote Benjamin Henry Latrobe, the architect of St. John's Church. With the encouragement of Dolley Madison in 1816, the church was built across from the White House, and although she was raised a Quaker, her baptism, confirmation and, years later, her funeral services were all held in St. John's. Nearly every president since Madison has attended services at the church, which was nicknamed the "Church of the Presidents." Pew 28 is permanently reserved as the president's pew. Two stained-glass windows memorialize Presidents Madison, Monroe, Van Buren, Harrison, Tyler and Taylor. President Arthur dedicated a stained-glass window to his wife, and President Monroe donated the steeple bell.

Simplicity and practicality distinguish the church's design. Originally the church was in the shape of a Greek cross. A pulpit on

wheels was set on a track that bisected the brick floor. One Sunday, the wheels came unclasped and the pulpit and bishop "glided away... faster and faster toward the side wall, gaining rapidly as it went." The end of that notable journey was also the end of the moveable pulpit. The little church was nearly razed in the 1880s when more space was needed for the growing congregation. Instead, St. John's championed the congressionally chartered Washington National Cathedral Foundation, which started the construction of the sixth largest cathedral in the world. Strengthened by time, St. John's Church continues to inspire and proudly perform a semiofficial role in Washington's social and political life.

6. Old State, War and Navy Building
(17ᵀᴴ Street at Pennsylvania Avenue, NW)

When the State, War and Navy Building was completed in 1888, after seventeen years of construction, the engineers proudly proclaimed, "She's plumb, and she's square, and boys, she's

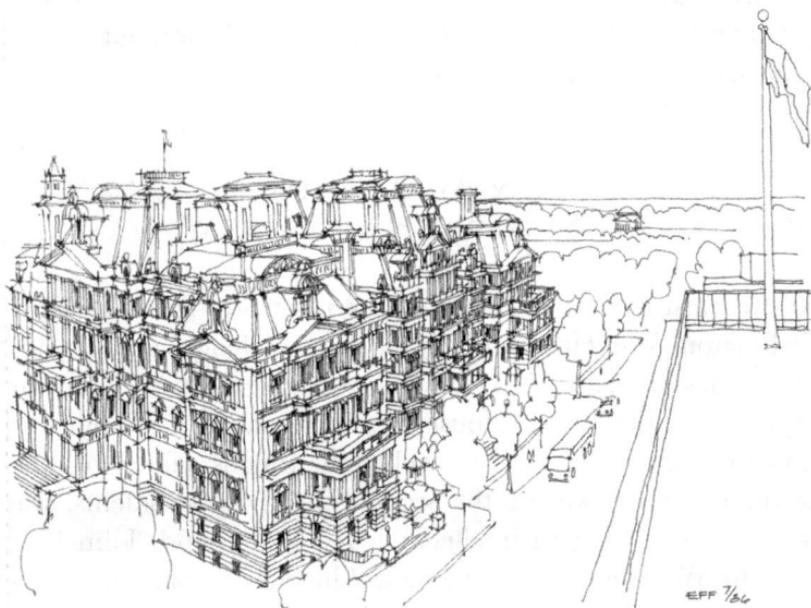

Old State, War and Navy Building. *By Edward F. Fogle.*

25

pretty." Sixty years later, however, President Truman described it as "the greatest monstrosity in America" and suggested that it should be razed and replaced. This "wedding cake" building, designed by Alfred Mullet, was described as the largest granite structure in the world. It has 553 rooms, 1,572 windows and 1,134 interior doors, most fitted with brass doorknobs embossed with the insignia of the State, War or Navy Departments. The four thousand polished bronze staircase balusters inspired one of the ladies cleaning the staircase to comment, "It looks like a golden stairway to heaven." More than one thousand treaties were concluded in the building before the State Department finally vacated its offices in 1947. The War and Navy Departments had been relocated years earlier. The executive branch of the government quickly occupied the empty office space, and the secretary of the navy's former office was appropriated by the vice president. A marble-walled Indian Treaty Room, in which no Indian treaties were ever signed, is now used for press interviews, meetings and parties. The building, renamed the Eisenhower Executive Office Building, has now been officially designated "a treasure." One admirer commented, "She has all the requisites of a great aunt: she is neither very pretty nor elegant, but she has enduring qualities of character."

7. HAY ADAMS HOTEL
(16TH STREET AT H STREET, NW)

On the most exclusive corner of the most prestigious block in Washington, John Hay and Henry Adams built adjoining homes. Forty years later, in 1927, on that same site across Lafayette Square from the White House, a premier hotel was built and named to commemorate the two lifelong friends. Henry Adams, the direct descendant of the second and sixth presidents, was known as a gentleman intellectual. His best friend, John Hay, came to Washington as President Lincoln's private secretary and later served as secretary of state under William McKinley and Theodore Roosevelt. Hay and Adams chose to live in

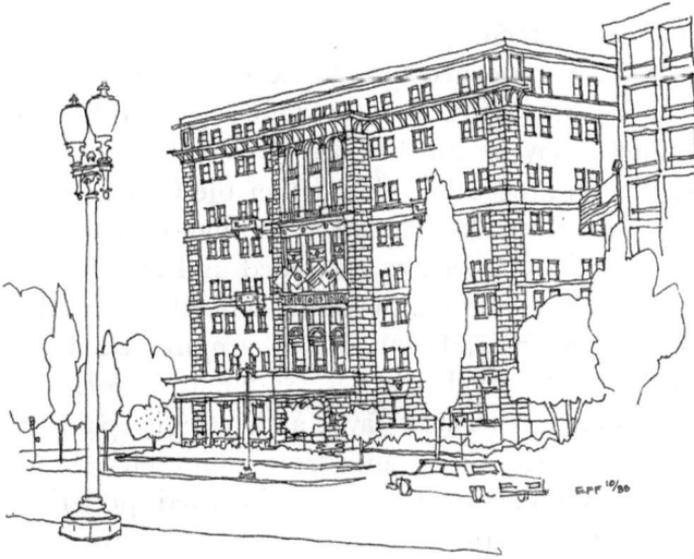

Hay Adams Hotel. *By Edward F. Fogle.*

the president's neighborhood because, as Adams once wrote, "Lafayette Square is Society." Developer Harry Wardman razed the Hay and Adams houses in order to build the hotel. This prominent location has appealed to celebrity guests like Charles Lindbergh, Sinclair Lewis and President Obama before his inauguration. Adams once wrote that he and Hay "had the advantage of looking out their windows on the antiquities of Lafayette Square." That time-honored view now belongs to the guests of the historic Hay Adams Hotel.

8. Willard's Hotel
(14th Street at Pennsylvania Avenue, NW)

Henry Willard worked miracles with the old City Hotel when he took over the management in 1847. He believed that the reputation of a good hotel was dependent on accommodating famous guests and providing lavish banquets and meals. President-elect Lincoln stayed at Willard's Hotel, as did vice

presidents, statesmen, diplomats, actors and writers like Julia Ward Howe, who penned the "Battle Hymn of the Republic" during her stay. Nathaniel Hawthorne shrewdly observed, "This hotel...may be much more justly called the center of Washington and the Union than either the Capitol, the White House, or the State Department." Throughout the nineteenth century, Willard's Hotel was expanded and improved. Henry Willard's nephew inherited the old-fashioned hotel and quickly replaced it with a magnificent, Second Empire–style building in 1904. For decades, Willard's was Washington's premier hotel, until it gradually fell out of favor and into disrepair. In 1968, when Willard's was closed and demolition seemed imminent, sentimental Washingtonians and concerned preservationists revived an interest in the historic merit of the old structure. After years of struggle and neglect, Willard's was saved, renovated and reopened in 1986. Once again, this grande dame of hotels can be called the "Crown Jewel of Pennsylvania Avenue."

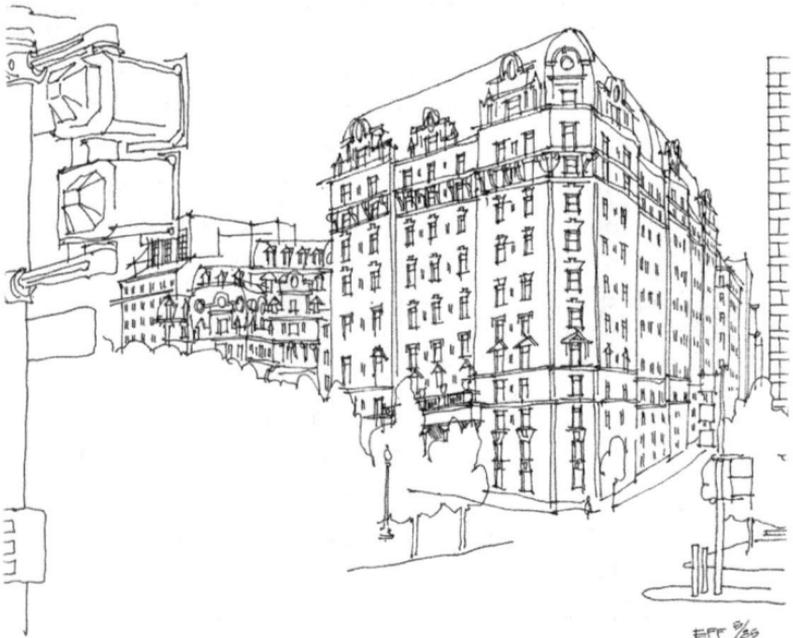

Willard's Hotel. *By Edward F. Fogle.*

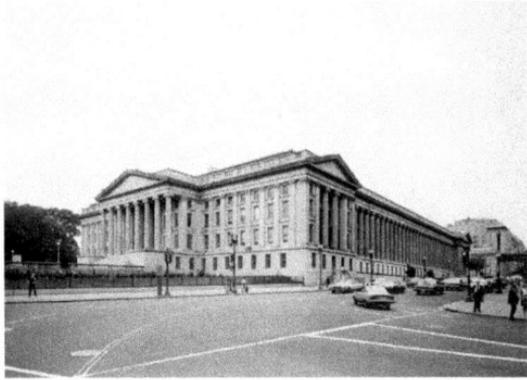

Department of the Treasury. *Courtesy of the Library of Congress HABS/ HAER/HALS.*

NOT TO BE MISSED

9. Department of the Treasury
(15th Street at Pennsylvania Avenue, NW)

Under construction for thirty-three years, the Greek Revival–style Treasury Building is the oldest and the longest continually occupied government departmental building in Washington. The architectural style has greatly influenced the design of many later government buildings. Robert Mills was the architect of the monumental granite structure in 1833. Inside, daily financial government business was conducted in the marble-walled Cash Room for over one hundred years. South of the building stands the statue of Alexander Hamilton, the first secretary of the treasury and a brilliant financier who also left a huge national debt. Facing Pennsylvania Avenue, on the north, is the statue of Swiss-born Albert Gallatin, Jefferson's treasury secretary, who within six years paid off the debt.

10. Blair House
(1651 Pennsylvania Avenue, NW)

Francis Preston Blair, the editor of the *Globe Newspaper*, purchased the ten-year-old, Federal-style house across from the White House in 1836. Blair's son, Montgomery, later moved into the house while

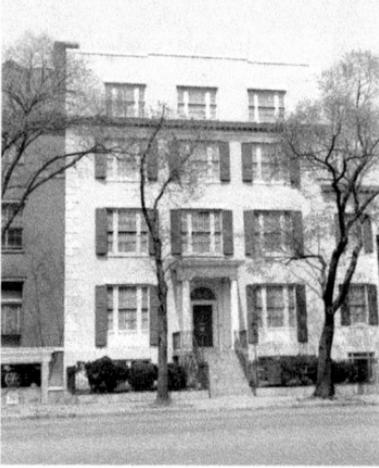

Blair House. *Courtesy of the Library of Congress HABS/HAER/HALS.*

he served as President Lincoln's postmaster general. His son, Gist, inherited the house and lived there until his death in 1940, when the government purchased and designated it as a guesthouse for the president's official visitors. Blair House also served as a temporary presidential residence from 1948 to 1952 when President Truman moved in during major White House renovations.

11. Lafayette Square Row Houses
(Madison Place and Jackson Place, NW)

Dolley Madison returned to live in the house across from St. John's Church in 1836, after the death of her husband. She was Washington's most beloved, admired and sought-after first lady until her death in 1849. Admiral Charles Wilkes, who circumnavigated the globe from 1838 to 1842, purchased the Dolley Madison house, and his family owned it for thirty years. From 1879 until 1950, the Cosmos Club, a literary and scientific organization, occupied the house. Senator Dan Sickles was living in a house across Lafayette Square when he murdered Phillip Barton Key (son of Francis Scott Key) for having a torrid affair with his wife. Major Henry Rathbone lived three houses away from Sickles's home when President Lincoln invited him to be a guest at Ford's Theatre the night the president was shot. In the twentieth century, the Lafayette

Square houses, once occupied by vice presidents, congressmen and statesmen, became offices, occupied by organizations like the Pan American Union, Carnegie Peace Endowment and the Brookings Institute. A few houses were razed and replaced, in the late 1920s, with office buildings.

12. U.S. Chamber of Commerce and the Treasury Annex
(1615 H Street, NW) and (Madison Place at Pennsylvania Avenue, NW)

As early as 1901, Congress proposed razing all houses facing Lafayette Square and replacing them with Neoclassical-style buildings. Architect Cass Gilbert designed the first of these buildings in 1919 for the Treasury Annex and the second in 1922 for the U.S. Chamber of Commerce. The Great Depression and two wars temporarily halted further construction. By the 1960s, massive Modernist structures were proposed to replace the remaining houses. Jackie Kennedy worked diligently, behind the scenes, to preserve the historic character of the old neighborhood. She saved the Lafayette Square houses, and the new office buildings were redesigned to be attached to, but built behind, the historic homes.

13. Five Statues of Heroes
(on the Four Corners and in the Center of Lafayette Square)

The statue of General Andrew Jackson, the first elected president of the Democratic Party, stands in the center of Lafayette Square. Designed by Clark Mills in 1848, it is the first cast-bronze equestrian statue in the United States. On the four corners of the square are statues of foreign-born Revolutionary War heroes. The northwest corner is dedicated to the Prussian baron von Steuben, who rapidly trained the American troops into a disciplined force. The statue on the northeast corner represents the Polish general Tadeusz Kosciuszko, who supervised the construction of the fort

at Saratoga, New York. On the southwest corner is the statue of the French comte de Rochambeau, who, with seven thousand troops under his command, helped win the Battle at Yorktown. The statue of the Marquis de Lafayette, for whom the square is named, stands on the southeast corner. The nineteen-year-old Lafayette, hero of the Revolutionary War, volunteered his fortune and his life (in 1777), and he served throughout the war under General Washington.

Capitol Hill Neighborhood

The first description of Capitol Hill was Pierre L'Enfant's 1791 flowery report to George Washington: "[It] stands really as a pedestal waiting for a superstructure." The high plateau, not really a hill, was the site that L'Enfant, the city's planner, chose for "the Federal House" (the Capitol). Daniel Carroll, a twenty-six-year-old, wealthy, well-connected businessman, owned much of this land, and he felt confident that it would become the principal center of Washington society. L'Enfant was at odds with anyone who did not comprehend his vision for the city, especially Daniel Carroll, who had begun to build his new mansion at the base of Capitol Hill. L'Enfant warned Carroll that his house intruded into a planned street and it must be removed. Carroll responded that the street was just a sketch on a map that should be redrawn. A passionate quarrel erupted. Carroll briefly left town to secure an injunction against L'Enfant, who took advantage of Carroll's absence and had the house dismantled. Carroll's house was eventually relocated and rebuilt; it became the first important house built in Washington. Regrettably, it was razed in 1886. L'Enfant, unfortunately, was immediately relieved of any further responsibilities related to designing the city. His brilliant plan, however, endured.

Capitol Hill is the oldest residential area in old Washington City. Two sections of this early neighborhood developed simultaneously. The first was near the Capitol, where local

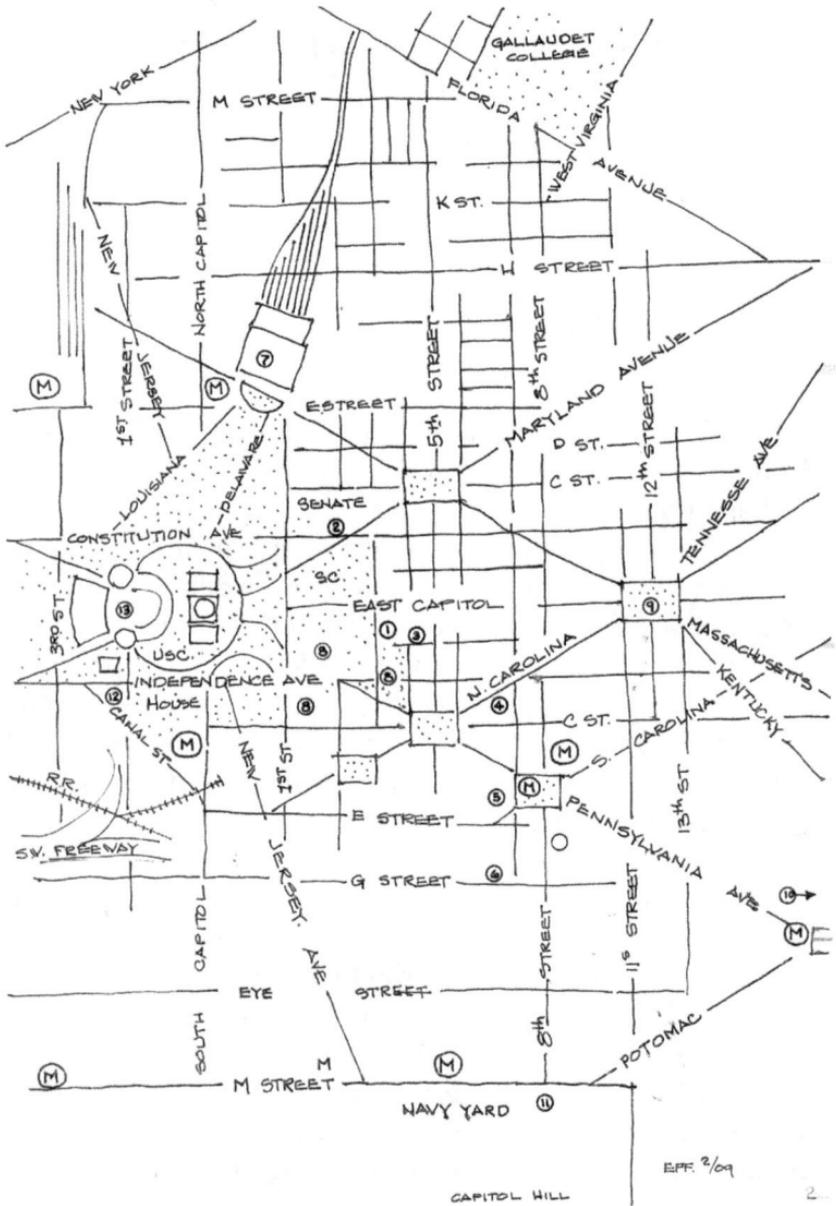

Map of Capitol Hill. *By Edward F. Fogle.*

Capitol Hill Neighborhood

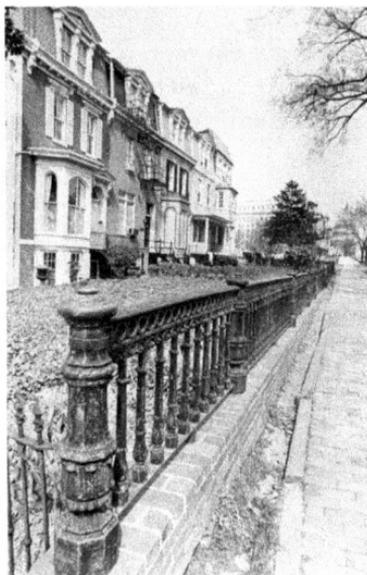

Row houses on New Jersey Avenue, SE, Capitol Hill. *Courtesy of the Star Collection, D.C. Public Library.*

laborers building the Capitol lived in wooden shanties. Nearby, the skilled workers lived in small frame and brick houses, and the federal workers occupied the larger, free-standing dwellings. The second area to develop was southeast of the Capitol, near the Anacostia River. Small, attached row houses were built by the workers at the Navy Yard, which was the major employer in Washington for 150 years. Daniel Carroll built a row of handsome boardinghouses in 1805, across the street from the Capitol. Many members of Congress, including Abraham Lincoln, lived there. These houses were razed when the Library of Congress (site 8) was built. Robert Sewall built the first grand, Federal-style house (site 2) two blocks northeast of the Capitol.

The Capitol Hill neighborhood grew slowly until after the Civil War, when midlevel government clerks embraced the idea of homeownership. The industrial age made building materials affordable, and the local brickyards offered "house pattern books" for inspiration. Although the development of Capitol Hill occurred in a piecemeal fashion, the end result is a low-rise, architecturally harmonious neighborhood. Large town houses stand next to two-story frame structures, mixed with groups of

identical, modest, brick row houses. Businesses thrived alongside residences. Eastern Market (site 4), a farmer's market first established in 1802, is the oldest continually operating farmer's market in the city.

In the twentieth century, Capitol Hill fell out of favor as a place to live. During World War II, many row houses became boardinghouses. Large sections of the neighborhood were considered "blighted and obsolete." The area was ripe for urban redevelopment. Fortunately, in the 1950s, a restoration movement was started on Capitol Hill and gradually the area was gentrified. Today, much of the Capitol Hill area is considered a historic district—the largest in the city, encompassing over 150 blocks. It looks much as it did at the end of the nineteenth century, which is a great tribute to private preservation efforts.

1. Folger Shakespeare Library
(201 East Capitol Street, SE)

"The biggest little library in the world" is one scholar's description of the Folger Collection of Shakespeareana. Henry Clay Folger attended a college lecture by Ralph Waldo Emerson, and the great transcendentalist's intellect, poetry, beautiful English and love of Shakespeare so inspired him that he began an earnest study of the Bard, which turned into a lifelong pursuit. After college, Folger clerked with a New York oil-refining business and rose in the ranks of the company to become chairman of the board of Standard Oil of New York. Although he became a millionaire, he and his wife, Emily, who shared his love of Shakespeare, lived modestly while quietly amassing an amazing collection of Shakespearean treasures, which they carefully catalogued and stored in vaults and warehouses.

In 1928, Folger decided to build a library in Washington to house his Shakespearean collection. A sleek, Art Deco–style library building was designed, with nine handsomely carved panels on the exterior marble walls depicting memorable moments from Shakespeare's most popular plays. The building contains a Tudor-

Folger Shakespeare Library. *By Edward F. Fogle.*

style exhibition hall, an Elizabethan theatre and an extensive reading room open to scholars. Rare books, manuscripts, relics, tapestries, prints, drawings, playbills, costumes and seventy-nine copies of the 1623 First Folio are only a few of the cherished items housed in the library. Unfortunately, Folger died before his library was dedicated, but he left a remarkable legacy to America. He had refused to give his collection to Great Britain, claiming instead that his ambition was "to help make the United States a center for literary study and progress."

2. SEWALL-BELMONT HOUSE
(114 CONSTITUTION AVENUE, NE)

Robert Sewall, a wealthy Maryland landowner, built his house on Capitol Hill in 1799, incorporating into the rear of it an older house located on the site. From 1801 to 1813, the house was leased to Albert Gallatin, the Swiss-born secretary of the treasury. On August 24, 1814, as British troops marched past

Sewall-Belmont House. *By Edward F. Fogle.*

the Sewall House toward the Capitol, shots rang out, fired by Captain Joshua Barney's marines. Several British soldiers were wounded and the horse was shot from under British general Robert Ross. In retaliation, the house was set on fire, but it survived total destruction when a major thunderstorm swept in and extinguished the flames. Sewall remodeled and rented the house, which remained in his family for 123 years. Vermont senator Porter Dale purchased it in 1922. Eight years later it was bought by suffragist Alva Vanderbilt Belmont as the new headquarters for the National Women's Party (NWP). Alice Paul, the legendary founder of the NWP, resided in the house for 43 years. A strong-willed activist, she spearheaded the movement that led to the ratification of the Nineteenth Amendment, giving women the vote. On display in the house are period furnishings, portraits, sculpture and Susan B. Anthony's writing desk. Greeting visitors in the front hall is the original banner that the suffragists carried to President Wilson's White House proclaiming, "We demand an amendment to the United States Constitution enfranchising women." Congress passed a bill

to restore the Sewall-Belmont House in 1984, when the Hart Senate Office Building was being built around it. Throughout its history, this house, considered the oldest on Capitol Hill, has been so significantly altered that it was described as "an interesting example of the development of architecture in the United States."

3. BRUMIDI HOUSE
(326 A STREET, SE)

This odd, wooden-frame house is rumored to have served briefly as the residence of Constantino Brumidi, the Capitol's great fresco artist. As a young man, Brumidi studied at the Academy of Arts in Rome and worked as an artist in the Vatican. "When about forty years of age, Brumidi threw away his brush and

Brumidi House. *By Edward F. Fogle.*

his great career, declaring that he would never paint another stroke until he had found liberty." Italy was at war and Brumidi volunteered as a soldier; however, he fought in vain for his country's freedom, was imprisoned and was eventually forced to flee Italy in 1852. He arrived in Washington in 1854 and was commissioned to decorate the Capitol's new interior spaces with historical and allegorical scenes. For twenty-five years, he worked in true fresco painting, which involves applying color pigments to wet plaster spread thickly over a wall or ceiling surface. When the plaster dries, the painted picture becomes a permanent part of the architecture. An amazingly versatile artist, Brumidi was also a designer, painter of portraits and master of numerous artistic styles. Brumidi's last residence on Capitol Hill was 921 G Street, SE, where he died in 1880. A naturalized citizen and fiercely patriotic, he lived out his American dream: "My one ambition and my daily prayer, is that I may live long enough to make beautiful the Capitol of the one country on earth in which there is liberty."

4. Eastern Market
(7TH Street at North Carolina Avenue, SE)

The oldest continually operating municipal farmer's market in Washington is Eastern Market on Capitol Hill. Originally located near the Navy Yard, Eastern Market suffered serious damage when the British invaded in 1814 and the Navy Yard burned. During the Civil War, the market lacked suppliers, and the "disgraceful shed" of a market house was almost closed for lack of business and torn down. German-born Aldolph Cluss, the prominent architect of many federal public works projects, designed a new building in 1871 for Eastern Market, with eighty-five vendor's stalls. The new location was several blocks nearer to the Capitol. In the 1920s, a new chain supermarket was opened across the street, offering stiff competition to the farmer's market. The city threatened repeatedly to replace Eastern Market with a streamlined supermarket, a national children's theatre and even a freeway. Two of the original

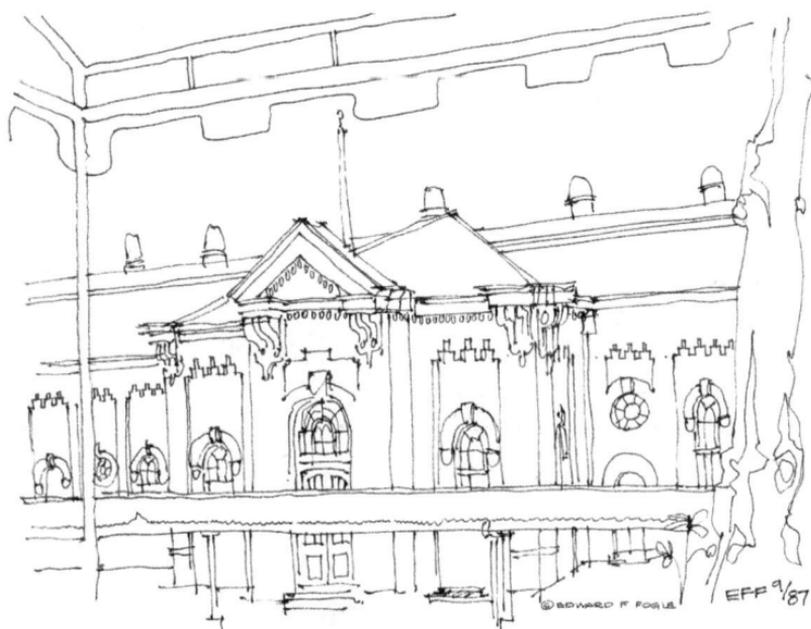

Eastern Market. *By Edward F. Fogle.*

farmer's markets had already been razed by 1961. With strong neighborhood support, however, Eastern Market survived not only the threats of demolition but also the riots of 1968, the 1980s plan to convert it into a tourist bazaar and a devastating fire in 2007. Eastern Market is still the heart of the Capitol Hill community. Six days a week, the market vendors sell groceries, produce and flowers. On the weekends, a local farmer's line, craft booths, antique dealers and street musicians transform the mundane routine of shopping into a joyous social exchange among merchants, customers and neighborhood friends.

5. The Maples
(630 South Carolina Avenue, SE)

"A fine house in the woods between Capitol Hill and the Navy Yard," wrote George Washington, describing the Maples. This

The Maples. *By Edward F. Fogle.*

exceptional house was built in 1795 by Captain William Mayne Duncanson, an English adventurer who had made his fortune in India. Duncanson lived in considerable splendor for a couple of years, but he invested heavily and unwisely in businesses both local and overseas. By 1799, his investments had failed and he was forced to live out his life in poverty, in a small cabin by the Potomac. In 1807, Thomas Jefferson recommended him for the position of librarian of Congress, writing, "He is, I think, a very honest man, came here a very wealthy one, has been swindled out of his whole property and now is in real distress." The job went to someone else.

The Maples stood vacant for many years. It was used temporarily as a military hospital before Francis Scott Key bought the house in 1815. Key probably leased the house until 1833, at which time he lived in it for a brief period. Later owners included a general, a senator, a count and the first female war correspondent, Emily Edson Briggs. Over the years, the new owners added porches, parlors, a wine cellar and a ballroom

decorated by the Capitol's fresco artist, Constantine Brumidi. Webster, Clay, Calhoun and even Lincoln were among the home's famous visitors. The Maples has long outlived the trees for which it was named. Emily Briggs's daughter-in-law lived in the house until 1936, when it was transferred to Friendship House, a social services organization that struggled to keep the property. In 2008, Friendship House moved out, leaving the Maples standing vacant once again.

6. CHRIST CHURCH OF THE NAVY YARD (620 G STREET, SE)

This fairytale Gothic structure is said to house the oldest Episcopal congregation within the limits of old Washington City. The first church services were held in the 1790s, in a nearby tobacco barn. Benjamin Henry Latrobe designed Christ Church in 1807, using decorative cast-iron columns to support the roof, which was the first known use of cast iron for that purpose. Several expansions have altered the original structure, including the 1824 north wing, the 1849 narthex and a Victorian bell tower that dominates the church's façade. Christ Church underwent three other renovations before the 1950s, when an attempt was made to restore the church's original character.

The church was given the nickname "the Church of the Navy Yard." Sunday morning attendance often included the commodore of the navy, the commandant of the marine corps and marine band leader John Philip Sousa, who was born nearby. In 1807, the congregation established the Washington Parish Burial Grounds nearby. A special section was reserved for the interment of government officials, and the burial grounds became known as Congressional Cemetery. John Philip Sousa's grave is located in a prominent spot near the chapel. Presidents Madison, Monroe and John Quincy Adams attended Christ Church. Thomas Jefferson was known to stop by the church, possibly just to inspect the architectural design. However, when Jefferson's religious sincerity was questioned, he responded, "No

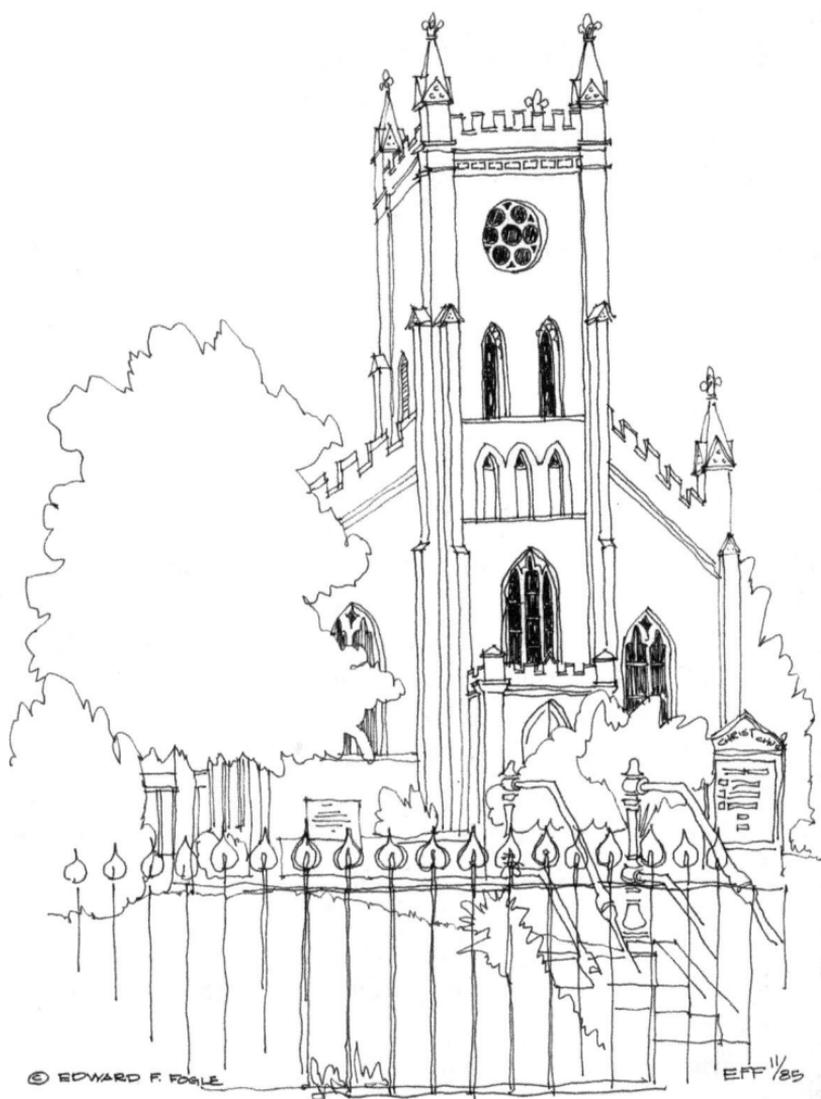

Christ Church of the Navy Yard. *By Edward F. Fogle.*

nation has yet existed or has been governed without religion. I, as chief magistrate of the nation, am bound to give it the sanction of my example."

7. Union Station
(Massachusetts Avenue at Delaware Avenue, NE)

"Make no little plans, they have no magic to stir men's blood," wrote Daniel Burnham, the architect of Union Station, which was completed in 1908. The station's triple-arched façade was inspired by the Arch of Constantine and the great waiting room was inspired by the Baths of Diocletian in Rome. Union Station was called a monument "to the progress of railroading and the art of traveling." In its heyday, an average of 220 trains and more than 200,000 travelers passed through the station daily. The station once housed a grand restaurant, Turkish baths, a bowling alley, an icehouse, a pharmacy, a resident doctor and even a mortuary.

A dramatic decrease in railroad usage caused legislation to be passed in 1968 changing Union Station into the "National

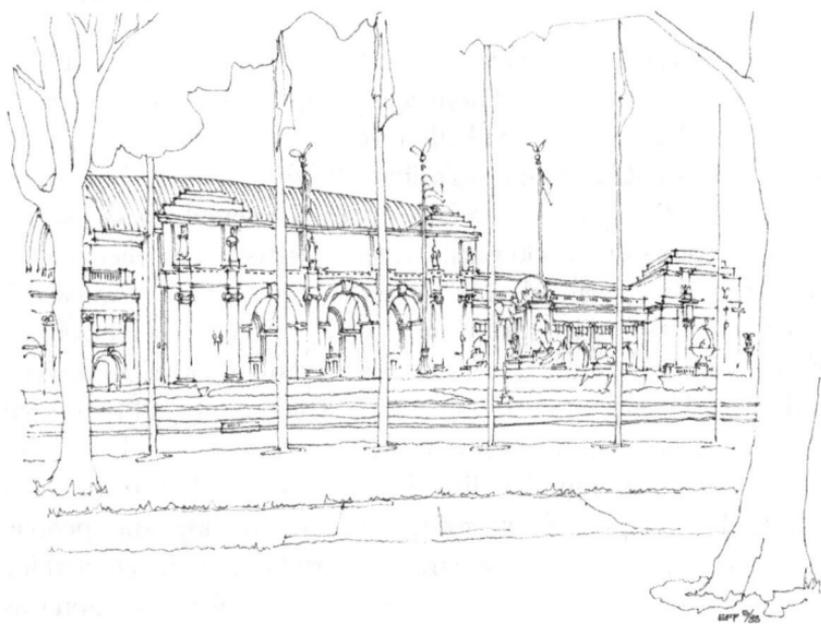

Union Station. *By Edward F. Fogle.*

Visitors Center" for the bicentennial celebration. The marble-floored waiting room was cut open to accommodate a big-screen slide show and the Savarin Dining Hall became the Government Bookstore. Proposed restaurants, shops and a parking garage were planned but not completed. A few years later, a hurricane caused serious roof damage; water leaks and rodents took over the building. Those arriving by train were not allowed to enter the station. In 1986, train travel was again becoming popular and plans were made for the restoration of Union Station. The ceiling of the palatial Great Hall was recast and regilded with seventy pounds of gold leaf. Shops and restaurants were opened for travelers, visitors and local residents. The sculpture and inscriptions were restored, including the one over the entry that proclaims, "A man must carry knowledge with him if he would bring knowledge back."

8. The Library of Congress
(1ST Street at Independence Avenue, SE)

"There is no subject to which a member of congress may not have occasion to refer," argued Thomas Jefferson in his speech before the Senate in 1815. Jefferson had offered 6,487 books from his personal library to reestablish Congress's library, which had been burned by the British. Thirty-five years later, in an accidental but disastrous fire, Congress lost 35,000 volumes, two-thirds of the collection. In 1864, a newly appointed congressional librarian named Ainsworth Rand Spofford pledged to bring Congress "oceans of books and rivers of information...free." He centralized all copyright activity within the library and requested that two copies of all registered items be deposited in the library's collection, free of charge. An international copyright law likewise increased the library's foreign works. The Capitol soon overflowed with books—and people. Congress requested that a separate library building be erected for this rapidly expanding collection. An architectural competition was held; a design was chosen, but debates about the plans continued in Congress for a decade. Finally, in 1889 ground was broken

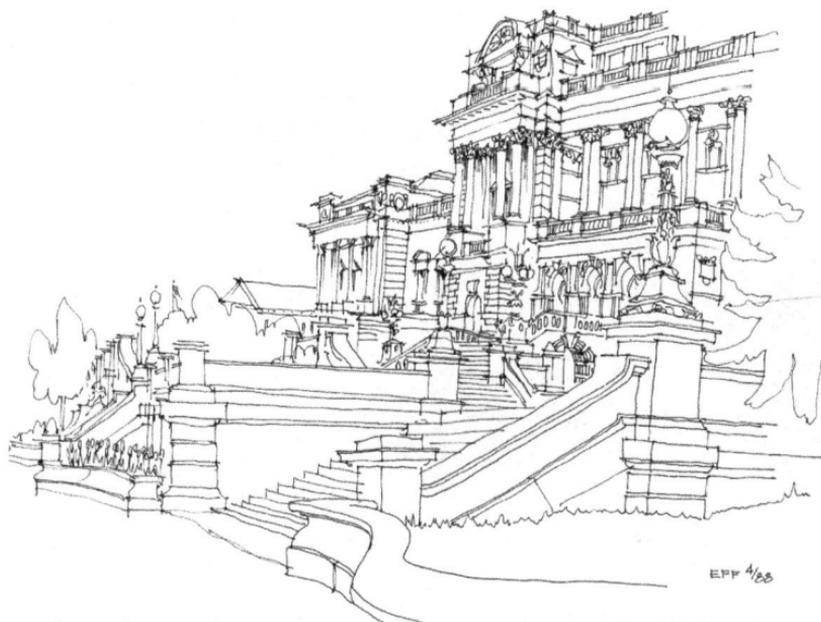

Library of Congress. *By Edward F. Fogle.*

for the new library that was said to be large enough to house the world's knowledge for the next one hundred years. Fifty American artists were chosen to decorate the building, working side by side with the Army Corps of Engineers, which built it. Together they created a "Cathedral to Knowledge." Approximately 140 million items in over 470 languages are partly housed on 535 miles of shelves in three huge, interconnected library buildings. The library, which increases by as many as 10,000 items a day, stands as one of Thomas Jefferson's greatest legacies to the nation.

Not to Be Missed

9. Lincoln Park
(East Capitol Street, Between 11th and 13th Streets)

Lincoln Park was one of the first sites in the nation dedicated to the slain president. In 1876, a statue was erected in the park

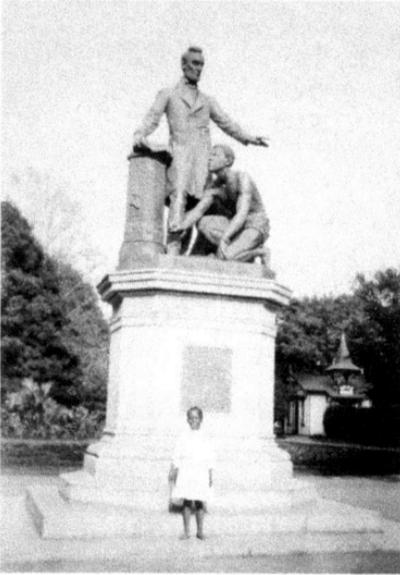

Lincoln Park. *Courtesy of the Library of Congress HABS/HAER/HALS.*

and paid for by the voluntary subscription of emancipated African Americans. The Emancipation Statue portrays Lincoln holding the Emancipation Proclamation with a newly freed slave beside him. A second statue was dedicated in Lincoln Park one hundred years later to the memory of Mary McLeod Bethune, one of America's leading African American educators. This delightful statue carries an inscription around the base from Bethune's "Last Will and Testament," which states "I leave you love…I leave you hope…[and] I leave you a responsibility to our young people."

10. Congressional Cemetery
(1801 E Street, SE)

Congressional Cemetery was founded in 1807 under the name of the Washington Parish Burial Grounds. It quickly became the local cemetery for government officials who died in office. Senators, representatives, a vice president and the Choctaw Indian chief Push-Ma-Ta-Ha were buried there in the early nineteenth century. Benjamin Latrobe designed a multitude of matching

Capitol Hill Neighborhood

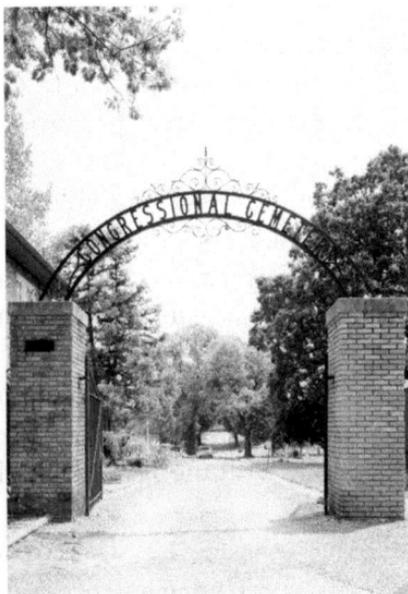

Congressional Cemetery. *Courtesy of the Library of Congress HABS/HAER/ HALS.*

sandstone cenotaphs, which were erected by the government to honor those members of Congress who died in office, whether they were buried there or not. Senator Hoar, in 1877, noted that "the prospect of being interred beneath one of these atrocities added a new terror to death."

11. Washington Navy Yard and Marine Barracks
(9th Street at M Street, SE) and (8th Street at I Street, SE)

The Navy Yard, established in 1799, is the oldest facility of its kind in the United States. Benjamin Latrobe designed the impressive Navy Yard Gate as an official entry point for important visitors arriving by ship. The overly optimistic government plan for making this area into a busy military and commercial port was never realized. However, the Navy Yard was Washington's major employer for 150 years, through shipbuilding, ordnance production, research and development and administrative operations. In 1963, the Navy Museum opened at the Navy Yard, displaying more than five thousand historical naval artifacts. Nearby is a museum ship, the USS

Barry, a decommissioned destroyer permanently moored at the Navy Yard docks.

President Thomas Jefferson selected the site for the Marine Barracks in 1801 because it was in proximity to the Navy Yard and "within easy marching distance" of the Capitol. The marine band, which was nicknamed "the President's Own," was headquartered at the Marine Barracks. The band has performed for every president since John Adams, and in the 1880s Capitol Hill native John Philip Sousa brought the band international acclaim. During the summer months at the Marine Barracks, "the President's Own" continues to offer free performances for the public with the Friday Evening Parades.

12. Bartholdi Fountain
(Independence Avenue at 1ˢᵗ Street, SW)

One of the first large public fountains placed in Washington was actually designed for the Philadelphia Centennial Exposition. The artist, Frederic Bartholdi, also put on display in Philadelphia the sixteen-foot-high forearm of his Statue of Liberty holding the torch. To raise money for the completion of his Statue of Liberty, Bartholdi offered the fountain for sale. Congress purchased it and prominently displayed it on the west front lawn of the Capitol. Bartholdi named the fountain "Fire and Water" because gaslights circled the upper basin, with water flowing between them. Congress replaced the gaslights with one of the earliest displays of outdoor electric lights, making the fountain one of Washington's most popular nineteenth-century tourist attractions.

13. Grant Memorial, Garfield Memorial and the Peace Monument
(1ˢᵗ Street, West of the Capitol)

One of the largest sculptures ever commissioned by Congress, yet one of the least visited, is the Ulysses S. Grant Memorial. A

relatively unknown artist, Henry Merwin Shrady, was chosen to design it. Shrady was a self-taught artist and a meticulous worker who was a stickler for details, especially regarding Civil War history and military accoutrements. He spent twenty years working continually on the memorial and died two weeks before its dedication in 1922, the centennial of General Grant's birth. The figure of Grant appears calm, distant and sullen as he sits astride an alert and agitated horse. To the north is the cavalry group of seven horsemen charging into battle. The action is intense, as one horse has stumbled and the rider is about to be trampled, with only one rider aware of his plight. To the south is the artillery group of three soldiers, all bearing grim expressions. They are driving a caisson carrying a cannon, pulled by three horses. One of the horses has broken its bridle strap and is pulling wildly out of control. The ground under the caisson is muddy and littered with battle debris. No other memorial has rivaled what Shrady accomplished in capturing the drama of the war in bronze.

"No man ever started so low that accomplished so much in all our history," said President Hayes in praise of James Garfield. He overcame poverty and disadvantage to become an extraordinarily brave war hero. During his eighteen years in Congress, he proved himself a respected leader and popular orator. But after only four months as president, he died from an assassin's bullet. Civil War veterans who had served under Garfield made sure that their beloved leader would be remembered. A memorial was dedicated to Garfield in 1887 that depicts him offering his inaugural address and features allegorical figures representing different aspects of his life: the scholar, the soldier and the statesman.

America weeps on the shoulder of History in the Peace Monument, which was originally named the Navy Monument and was dedicated to naval heroes who died at sea during the Civil War. "They died that their country might live" is the inscription on the book held by the female allegorical figure representing history. A Victory figure looks toward the White House, crowning the sacrifices of officers, seamen and marines.

The Peace figure, for which the monument was renamed, faces the Capitol. In her extended right hand is an olive branch. Nearby, a dove rests on a sheaf of wheat, and emblems on the base, representing science, literature and art, symbolize the progress that comes with Peace.

Georgetown Neighborhood

Washington's history began in Georgetown, a busy eighteenth-century shipping port city where fleets of locally owned ships conducted trade worldwide. The bustling town had numerous inns and taverns. Conestoga wagons rumbled past the shops that lined the streets, and on the heights were fine country estates and scattered farms.

In 1622, Captain Henry Fleete first discovered the port, which was an Indian village named Tohoga, where he established a fur trading business. By 1703, the village was abandoned, but the surrounding land was granted to Ninian Beall, who named his property the Rock of Dumbarton. The name survives through the old estates, Dumbarton House (site 3) and Dumbarton Oaks Estate (site 4). By mid-century, several aristocratic families operated very large plantations. They built mansions in town, like Halcyon House (site 12), from which to conduct their business. In 1751, the "Town of George" was officially named in honor of King George II of England.

In 1789, George Washington considered Georgetown to be the greatest tobacco market in the United States. The next year, Georgetown became a part of the District of Columbia. With the arrival of Congress in 1800, Georgetown's economy began to falter. Local businessmen who had invested in the new city of Washington were soon overextended and lost their fortunes. The Potomac River silted and became difficult to navigate. The Chesapeake and Ohio (C&O) Canal was a financial disaster for investors, though

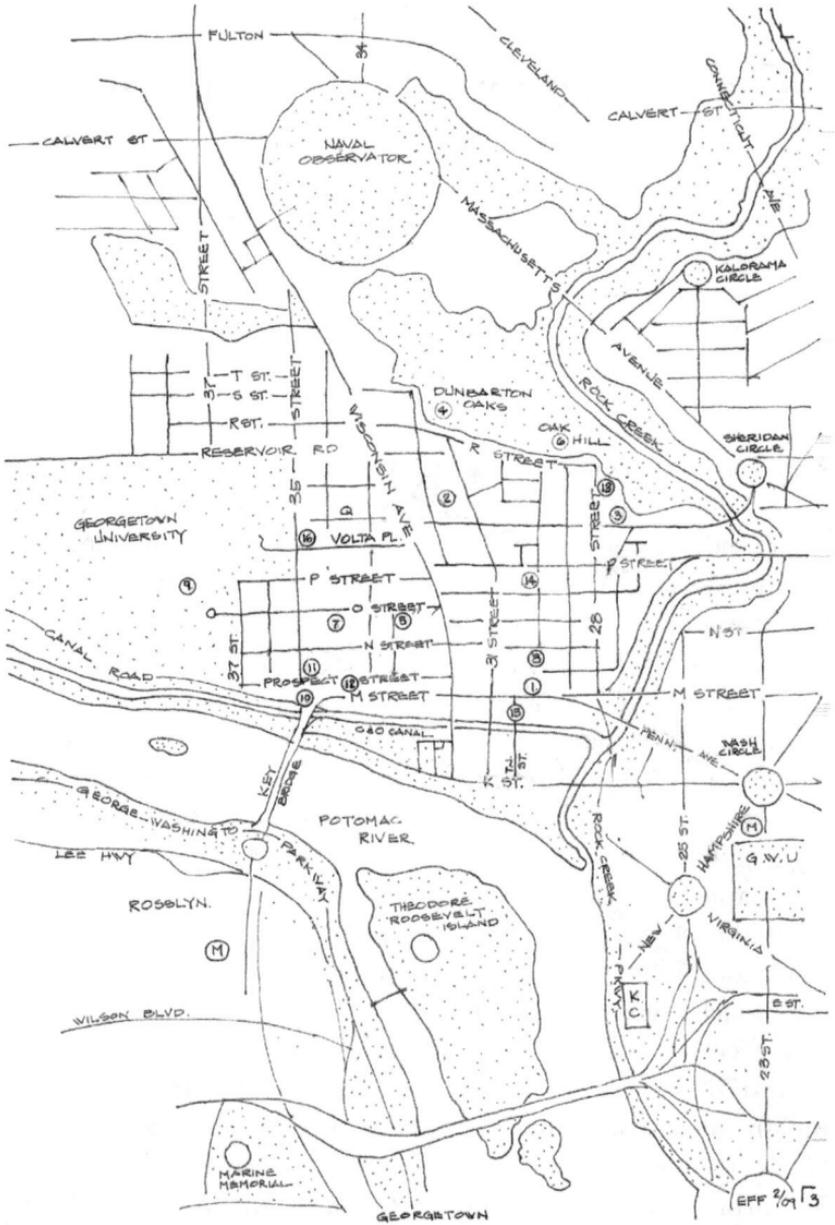

Map of Georgetown. *By Edward F. Fogle.*

Georgetown Neighborhood

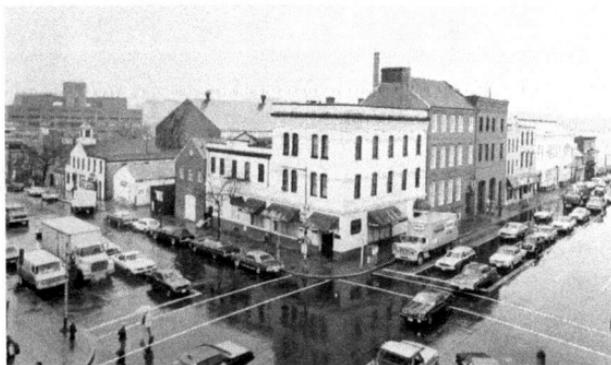

Georgetown,
Wisconsin Avenue
at M Street, NW.
*Courtesy of the Star
Collection, D.C.
Public Library.*

it operated for nearly one hundred years. The Civil War had a devastating effect on Georgetown because many residents held Southern sympathies. Tudor Place (site 2) was nearly confiscated by Union troops for hospital use, and most students at Georgetown University chose not to stay. In 1871, Georgetown's city charter was revoked, and Georgetown became just a neighborhood within the expanded city of Washington.

At the start of the twentieth century, most of Georgetown's wealthy residents moved to Lafayette Square or Dupont Circle, and Georgetown became a blue-collar neighborhood. When Franklin Roosevelt's "New Dealers" were encouraged to restore the great Georgetown mansions, the old port city began its transformation. On the 200th anniversary of the naming of Georgetown, in 1951, historic designation was given to the neighborhood. Many of the lower- to middle-class residents, both black and white, moved out as real estate values skyrocketed. When the Kennedys moved to Georgetown, the area's popularity was renewed. Trendy shops and fashionable restaurants opened, new condominiums were built in waterfront warehouses and, once again, Georgetown's good reputation was restored.

1. The Old Stone House
(3051 M Street, NW)

Local folklore saved the Old Stone House, which is Georgetown's only surviving pre–Revolutionary War building. In the 1890s, a

Old Stone House. *By Edward F. Fogle.*

sign on the property read "George Washington's Headquarters," implying that the first president stayed there while discussing the plans for the new federal city. Christopher Layman, a cabinetmaker from Pennsylvania, built the first floor of the house in 1766 but died the next year. An upper-middle-class widow, Cassandra Chew, acquired the property and added the large kitchen, a second floor with two parlors and a stylish dining room and a third floor with three small bedrooms. In the early 1800s, John Suter Jr., a watchmaker, rented the first floor. He is thought to have built the home's only original piece of furniture, a grandfather clock. His father, John Suter, owned a tavern nearby where George Washington met with the local landowners in 1791. The Old Stone House had been used briefly as a tavern, leading to the confusion a century later. The house often served both as a residence and a shop, occupied by a printer, a tailor,

a painter and glazer and, finally, a used car dealer. Rumors of razing the Old Stone House inspired Georgetown residents to save it from destruction and restore it. In 1953, Congress declared it a National Historic Site, purchased the building and grounds and opened it to the public in 1960.

2. Tudor Place
(1644 31ST Street, NW)

Tudor Place, designed by the Capitol's architect, Dr. William Thornton, has been called the "brightest jewel in the crown of old houses in Georgetown." Built in 1802 by Thomas Peter and his wife, Martha (Martha Washington's granddaughter), this house had an unbroken chain of family ownership. The Peters had three daughters named America, Columbia and Britannia. By 1850, Britannia was widowed with an infant daughter. She returned to live at Tudor Place, where she would remain for the rest of her

Tudor Place. *By Edward F. Fogle.*

long life. Her cousin married Robert E. Lee, and at the beginning of the Civil War the government tried to seize Tudor Place for hospital use. Britannia announced that she would open the house to Federal officers for their living quarters, "on condition that affairs of war should not be discussed in her presence." Before the officers arrived, she carefully stored away all of the valuable Washington family relics. Britannia saved the house and, later, meticulously documented its contents because she understood their importance to future generations. She was close to her grandson, Armistead Peter Jr., who inherited the house upon her death. His son, Armistead Peter III, assumed responsibility for the care of the home when his father died. He jokingly observed, "Time slept for those who lived at Tudor Place." Upon his death in 1983, Tudor Place Foundation was established, opening Tudor Place to the public. This unique home offers a rare glimpse of two hundred years of Georgetown's cultural history. It stands as a monument to one family who safeguarded the architectural glory and historical importance of the home, as a sacred trust and a patriotic duty.

3. Dumbarton House
(2715 Q Street, NW)

Throughout its long history, Dumbarton House has been called by many names. Built in 1799, the house is a rare architectural example in Washington of late eighteenth-century Federal-style craftsmanship. In 1805, Joseph Nourse, register of the treasury, purchased the house and named it Cedar Hill. Seven years later, Charles Carroll bought it and renamed it Bellevue. Carroll was a friend of President and Mrs. Madison, and when the British burned Washington in 1814, he helped Dolley Madison escape from the White House. Samuel Whitall rented Bellevue in 1820; several years later, his son purchased the house from the Carroll estate. His daughter, Sarah, was born at Bellevue and lived there until 1896. After she married Charles Rittenhouse, Bellevue became known as Rittenhouse Place. John Newbold bought

Dumbarton House. *By Edward F. Fogle.*

Bellevue, but soon after, in 1915, Q Street was extended to the bridge that crossed Rock Creek. The house was lifted onto huge rollers and slowly pulled by horses to its present location, one hundred yards north of the original site. Bellevue was renamed Dumbarton House in 1928, when it was purchased, lovingly restored and beautifully furnished as the headquarters for the National Society of the Colonial Dames of America.

4. Dumbarton Oaks Estate
(3101 R Street, NW)

A baronial, late Georgian-style mansion was built in 1800 by William H. Dorsey, who named it Acropholus ("Grove on the Hill"). John Calhoun lived at the estate while serving as vice president, a job that, he joked, left him "ample leisure to study the fundamental questions of the day." Edward Linthicum, a

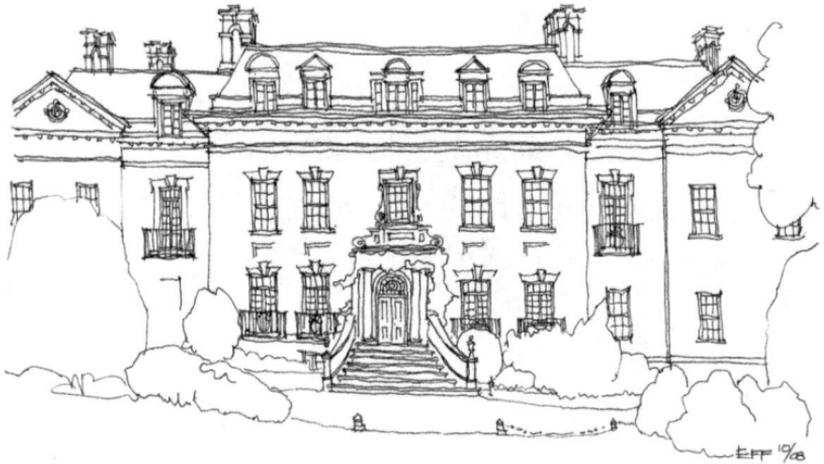

Dumbarton Oaks Estate. *By Edward F. Fogle.*

successful hardware merchant, bought the estate in 1846. He named it Monterey and spent twenty years remodeling it. The next owner renamed it the Oaks, and in 1920 Mr. and Mrs. Robert Woods Bliss bought the estate, added "Dumbarton" to the name and spent twenty years restoring it. Mrs. Bliss joined forces with landscape architect Beatrix Ferrand to create one of America's greatest gardens, featuring French, Italian and English garden designs. Mrs. Bliss's motto was a biblical phrase that she had inscribed on a garden bench: *Quod Severis Metes* ("As you sow, so shall ye reap"). Mr. and Mrs. Bliss established two museums on the property. The first is a repository for one of the finest Byzantine art collections in the world. The second contains over six hundred examples of pre-Columbian art, displayed in a glass-walled museum designed by Philip Johnson. In 1940, Mr. Bliss transferred the property to Harvard University. Four years later, Dumbarton Oaks was given a place in world history when, during World War II, it was used for an international conference that led to the establishment of the United Nations.

5. St. John's Church of Georgetown
(Potomac Street at O Street, NW)

In 1811, St. John's Church was described as "thronged to an overflow with all who were most elevated in station and in wealth...the pews in the gallery were rented at high rates and to persons of great respectability." St. John's of Georgetown is the second oldest Episcopal church in the District of Columbia. Dr. William Thornton, architect of the Capitol and Tudor Place, designed the church in 1807, though it has been altered over two centuries and the belfry was twice reconstructed. In 1831, the church was closed when the vestry failed to elect a rector. For seven years the only occupants were birds, bats and a sculptor who rented it for his studio. By 1838, church services began again but were disrupted during the Civil War. In 1880, another hindrance to the service was caused by two elderly sisters who lived in a house adjoining the church. Absolute hermits, they never mixed with the local population. Their food was drawn up

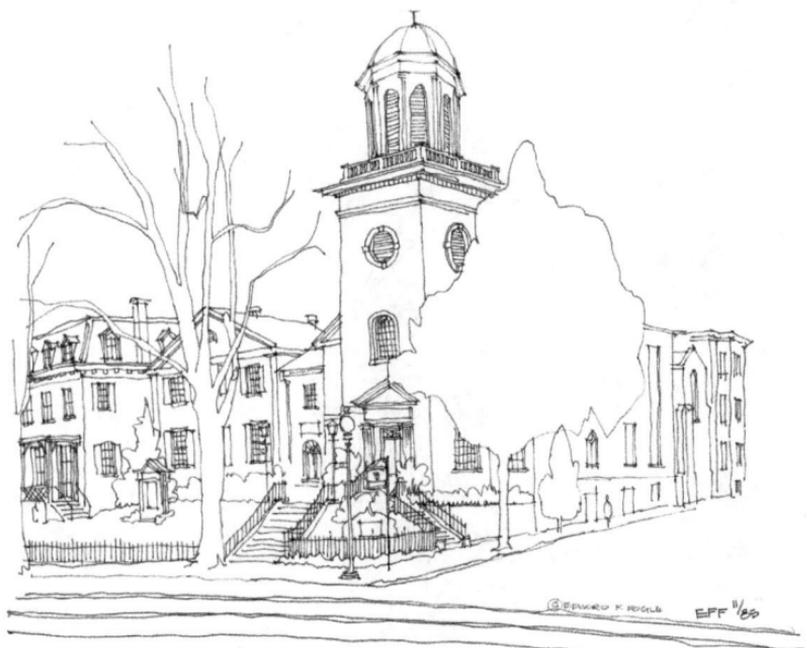

St. John's Church of Georgetown. *By Edward F. Fogle.*

61

in a basket, through a window. Their presence, however, was felt by St. John's congregation because when the organ was played, the two beat relentlessly on the wall with a hammer until the music ceased. With few other interruptions, however, services have continued at St. John's to the present day.

6. Oak Hill Cemetery Chapel
(3001 R Street, NW)

One of the most beautiful cemeteries in the country is Oak Hill in Georgetown, located on a hillside of Rock Creek Valley. William Wilson Corcoran, Washington's great nineteenth-

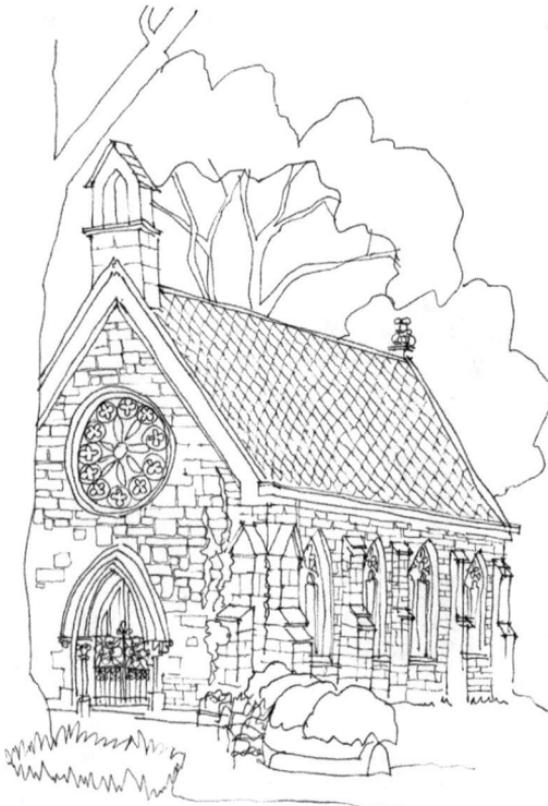

EFF ³/₈₁
OAK HILL CHAPEL

Oak Hill Cemetery Chapel. *By Edward F. Fogle.*

century philanthropist, established the cemetery in 1849 in memory of his wife, Louise, who died at the age of twenty-one. The cemetery, planned in the romantic English garden style, was described as "the happiest of cemetery." Oak Hill Chapel, a miniature American Gothic gem, was designed in 1850 by James Renwick, who also designed Corcoran's first art gallery in Washington and the Smithsonian Institution's first building, called the "Castle." The Smithsonian's first secretary, Joseph Henry, is buried in Oak Hill. Among the nineteenth-century notables buried in Oak Hill are Secretary of War Edwin Stanton, Joseph Willard of the Willard Hotel and the Russian count Baron Alexander De Bodisco. Near the entrance is the grave of John Howard Payne, who died in Tunisia in 1852 but whose body was brought back by Mr. Corcoran thirty years later. Payne's sentimental poem is still familiar today: "'Mid pleasures and palaces though we may roam, Be it ever so humble, there's no place like Home!"

7. Bodisco House
(3322 O Street, NW)

The imperial Russian minister Baron Alexander De Bodisco and his two nephews arrived in Washington in 1838. He took up residence in a house in Georgetown, which served for many years as the Russian Legation. In order to introduce his nephews to society, the baron hosted a fabulous Christmas party for the Georgetown children; among the guests was sixteen-year-old Harriett Beall Williams. Baron De Bodisco, a fifty-two-year-old bachelor, became completely enamored of Miss Williams. He was soon seen escorting her to school. One afternoon, when Harriett and her friends were walking in Georgetown, the baron's gilded carriage approached. Pretending not to see it, Harriett stepped into the street, stooped down and adjusted her shoe. The driver frantically pulled back on the horses, and as the startled baron watched, Harriett casually glanced up and winked. The baron was so infatuated with Harriett that he proposed marriage, but

Bodisco House. *By Edward F. Fogle.*

Harriett's family was strongly opposed to the match. She told him that "her grandmother and everybody else thought he was entirely too old and too ugly. Mr. Bodisco's reply was that she might find some one younger or better looking, but no one would love her more than he did." They were married in June 1839. Henry Clay gave Harriett's hand in marriage. President Van Buren, Dolley Madison and Daniel Webster were among the wedding guests. The house became the baron's wedding present to his bride, and it became home to their seven children.

8. LAIRD-DUNLOP HOUSE
(3014 N STREET, NW)

John Laird, one of Georgetown's most prosperous shipping merchants, moved into his newly built mansion in 1798. Over the years, several additions greatly enlarged the home, and small outbuildings, including the stable and smokehouse, were added.

Georgetown Neighborhood

Throughout the nineteenth century, the family continued the tradition of keeping a cow on the property, as well as hogs that they slaughtered each fall. In the garden rests a marker stone placed in 1751 denoting the original northern boundary of Georgetown. Laird's youngest daughter, Margaret, inherited the house and lived there with her aunt, Elizabeth Dick. Known as "Miss Peggy" and "Miss Betsy," they were well-loved figures in Georgetown society. Peggy left the house to her sister Barbara, who was married to Judge James Dunlop Jr. He served as a law partner with Francis Scott Key and was a chief justice of the Supreme Court of the District of Columbia. However, his strong Southern sympathies at the outbreak of the Civil War caused his removal from office by President Lincoln. In a twist of fate, Robert Todd Lincoln, the president's only surviving son, purchased the home from the Dunlop heirs in 1915, and it remained in his family until 1939. The Laird-Dunlop house has always served as a private residence and for several decades has been owned by former *Washington Post* newspaper executive editor Benjamin C. Bradlee and his wife, Sally Quinn.

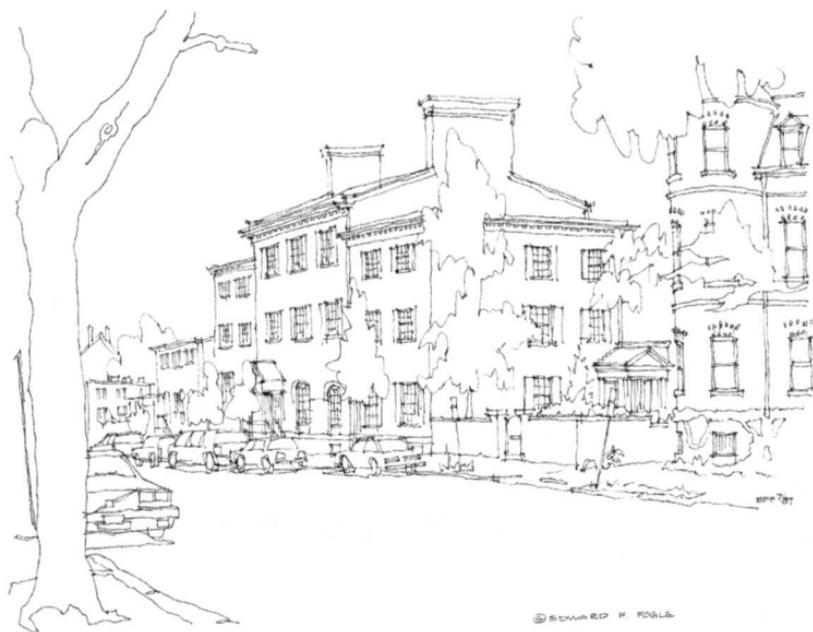

Laird-Dunlop House. *By Edward F. Fogle.*

NOT TO BE MISSED

9. Georgetown University
(37th Street at O Street, NW)

Georgetown University is the oldest university in Washington, the oldest Catholic college in the country and the only Catholic school to have reached a status akin to an Ivy League school. Archbishop John Carroll from Maryland, whose cousin was a signer of the Declaration of Independence, founded the Jesuit-run "Academy on the Potomac" in 1789. George Washington visited Georgetown University when his nephews were students, and he offered a speech at the building called "Old North," the oldest building on campus. During the Civil War, many of the campus buildings were occupied by Union troops because of the strong Southern sympathies held by many Georgetown students and Georgetown residents. In 1866, as a symbol of reuniting the North and South, the university adopted its official colors of blue and gray. Several years later, Father Patrick F. Healy, the son of a freed slave, was appointed to serve as the college's twenty-ninth president. Healy Hall was named in his honor and is the most recognizable building on campus, with its soaring stone spires and turrets.

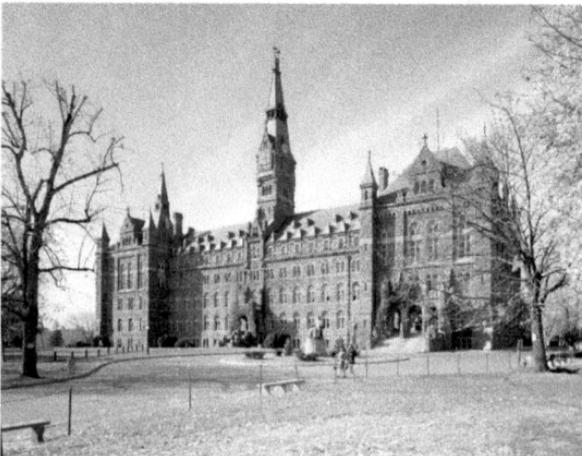

Healy Hall, Georgetown University.
Courtesy of the Library of Congress HABS/ HAER/HALS.

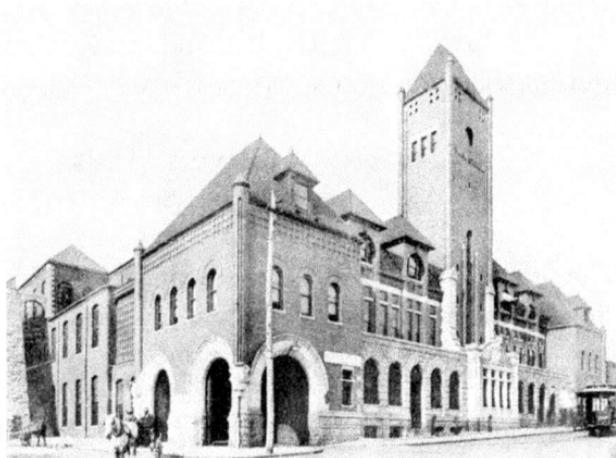

Car Barn. *Courtesy of the Library of Congress HABS/ HAER/HALS.*

10. The Car Barn
(36ᵗʰ Street at M Street, NW)

In 1894, a Georgetown streetcar station was built as a hub for four streetcar lines. Called the Car Barn, a name applied to older buildings that once housed horse-drawn trolley cars, this fancy streetcar station was a marvel of technology. The 140-foot central tower housed an elevator allowing passengers to transfer between the lower M and upper Prospect Street terminals. There were elevators inside used to carry streetcars to the upper levels for repairs. On the west side of the building is a seventy-five-step staircase, used by those who shunned the passenger elevator but made famous in the 1973 movie *The Exorcist.*

11. Quality Hill
(3425 Prospect Street, NW)

John Mason, nephew of George Mason, the author of the Bill of Rights, built one of the finest freestanding town houses in Georgetown in 1797 with bricks imported from England. Dr. Charles Worthington, surgeon of the Continental navy, purchased the house in 1810 and gave it the name Quality Hill. At the beginning of the century, Albert Adsit Clements, who owned Halcyon House, bought Quality Hill and used it to store his collection of antique buildings

materials. In the 1960s, Rhode Island senator Claiborne Pell bought Quality Hill, lovingly restored it and lived there for over forty years.

12. Halcyon House
(3400 Prospect Street, NW)

The first secretary of the navy, Benjamin Stoddert, built Halcyon House, which was named for the mythical bird that calmed the seas. Stoddert's fortunes waned and the house was sold several times before 1859, when John Kidwell bought it. A family feud over ownership lasted until 1900. Albert Adsit Clemons bought it, significantly altered it—adding wings and extra floors—and obliterated the original Georgian-style home behind an eclectic faux façade. In the 1980s, artist John Dreyfuss and his wife rescued the house and spent years renovating the property. After serving as Dreyfuss's artist studio for years, the house is up for sale.

13. Evermay
(1623 28th Street, NW)

A real estate speculator, Samuel Davidson, built one of Georgetown's great homes, called Evermay, in about 1800. He was known as an irascible bachelor and once placed an ad in the newspaper "to forewarn at their peril, all persons, of whatever age, color, or standing in society from trespassing on the premises." The property was inherited by a nephew in 1810 and sold several times until 1919, when a real estate promoter threatened to raze the home and subdivide the property. The Honorable F. Lammot Belin, former ambassador to Poland, purchased and saved the property. Three generations of the family have lived there for nearly a century, but they are now hoping to find a new owner.

14. Mt. Zion Church and Cemetery
(1334 29th Street, NW) and (27th Street at Q Street, NW)

Considered the first black church in Washington, Mt. Zion's congregation was established by 125 former members of what

is now Dumbarton Methodist Church. White preachers led Mt. Zion's congregation until 1864, when the first black pastor came to the church. The present church building was erected in 1875; much of the work was done by African American artisans and workmen. Before and during the Civil War, Mt. Zion was said to have been a way station in the Underground Railroad. A few blocks north of the church is the Mt. Zion and Female Union Band Cemetery. In 1842, a benevolent association of African American churchwomen formed the Female Union Band to buy land on which to bury free blacks. In 1879, Mt. Zion leased part of the cemetery for its burial grounds. Both cemeteries were closed to interments in 1953, and over the years the property was vandalized. In 1976, a legal battle was won to save the burial grounds as "a monument to black traditions in our nation's capital."

15. Chesapeake and Ohio Canal
(Visitor's Center at 1057 Thomas Jefferson Street, NW)

Ground was broken on July 4, 1828, for the C&O Canal. Completed in 1850, with seventy-six locks, it stretched 186 miles from Georgetown to Cumberland, Maryland. In the 1870s, coal and heavy merchandise were transported on the canal using hundreds of private barges. The canal provided an occupation for generations of workers until 1923, when it was closed because of hurricane damage. By the 1950s, the canal was in decrepit shape, and suggestions were made to drain, pave and transform it into a parkway. Supreme Court justice William O. Douglass led a hike for writers and officials along the towpath of the canal, convincing them to give the canal a second chance, and in 1971 it became a national historic park.

16. Volta Bureau
(1537 35th Street, NW)

The headquarters of the American Association to Promote the Teaching of Speech to the Deaf is located in the Volta Bureau.

Helen Keller broke ground for the classical buff brick building in 1893. The bureau was established in 1880 by Alexander Graham Bell with the Volta prize money he received for inventing the telephone. Bell was a teacher of the deaf, and while working on an electrical apparatus to enable the deaf to hear, he discovered the principles of reproducing sound electronically that led to the invention of the telephone. He perfected this invention while working across the street in a laboratory he maintained behind his parents' home at 1525 35th Street, NW.

Chapter 4

Old Downtown and Chinatown Neighborhood

The heart of old Washington was Center Market, located on Pennsylvania Avenue at 7th Street, NW. In the early nineteenth century, produce and merchandise were transported to market on barges via the city canal, once located where Constitution Avenue is now. Commercial development quickly spread to the north of Pennsylvania Avenue and westward in the direction of the White House. Pennsylvania Avenue and F Street were both important streets in the early development of the city, connecting the Capitol to the White House. Running north–south, 7th Street, NW, connected the outlying farmland to the Center Market and beyond, to the river wharves in southwest Washington.

Development along F Street was supported by the construction of three grand federal buildings, beginning in 1836: the Treasury, the General Post Office and the Patent Office (site 1). They were built seven blocks apart and were under construction for thirty years. Located between these major buildings on F Street were the residences for government workers, construction workers, artisans and professionals, along with shops, taverns, theatres, churches, synagogues and law offices. Before public transportation, people lived near where they worked. Commercial and residential buildings were often similar in appearance. Most were brick row buildings, two or three stories tall, often with steep, gabled roofs. Shops were located on the first floor and the residences above. A few of these old buildings have survived, like the Surratt House (site 2).

Map of old downtown and Chinatown. *By Edward F. Fogle.*

Old Downtown and Chinatown Neighborhood

Chinatown, 600 block of H Street, NW. *Courtesy of the Washingtoniana Division, D.C. Public Library.*

A strong German population settled along 7th Street beginning in the 1850s, reinforcing it as a commercial corridor and eventually replacing the buildings with new, taller ones used strictly for business. This was a neighborhood of hardworking and successful dry goods merchants and craftsmen. The German Catholics built St. Mary's Church on 5th Street, and the German Jewish community built several synagogues, the first of which was Adas Israel (site 8). Italians, Greeks and African Americans also moved into the old downtown area, but the biggest population shift occurred when the Chinese community suddenly relocated there in 1931. The first Chinese immigrants came to Washington in the 1880s and settled on Pennsylvania Avenue, around 4th Street, not far from the old railroad station. The Chinese immigrants rented buildings for their shops, restaurants and residences, and visiting tourists provided their main source of income.

In 1931, the government began construction of the new Federal Triangle office buildings in old Chinatown. The two local Chinese Merchants Associations were able to negotiate, through real estate agents, to obtain relocation space for their member businesses on H Street, between 5th and 7th Streets, NW. Almost overnight, what had been a German neighborhood was now occupied by Chinese, and the local property owners protested, saying, "It is just that we don't feel they will bring any business here." The old downtown neighborhood has been home to a wide variety of residents throughout its history. Within the last two decades, new construction has drawn a new, young population to the area. The new Verizon (formerly MCI) Sports Center, the new Convention Center and new shops, restaurants, apartment and condominium buildings, movie theatres, art galleries and even a modern bowling alley have transformed the area, and the old downtown has become new again.

A Neighborhood Guide to Washington, D.C.

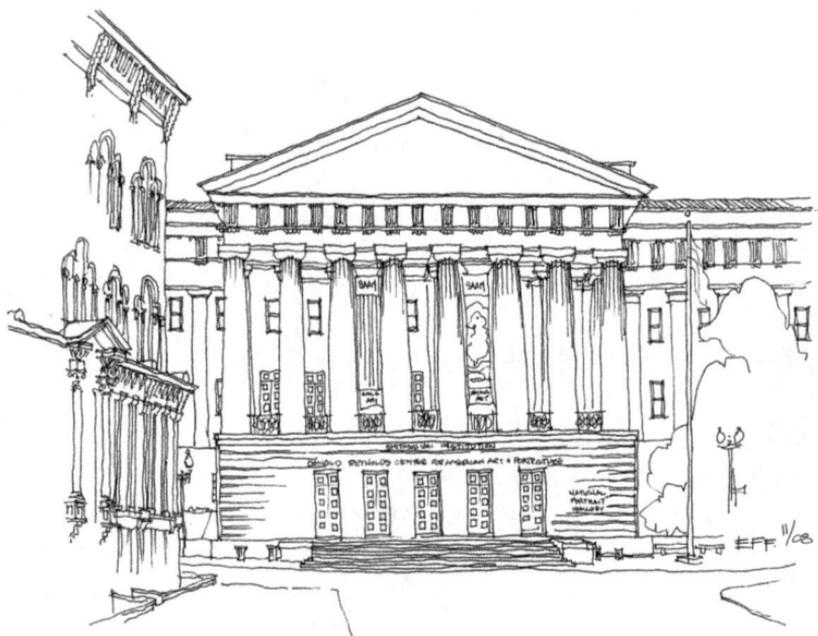

Old Patent Office. *By Edward F. Fogle.*

1. Old Patent Office
(7ᵀᴴ and 9ᵀᴴ Streets, Between F and G Streets, NW)

President Andrew Jackson had a plan to transform Washington into a world-class city by filling it with great Greek temple–like buildings. Before Jackson left office, construction had begun on the Patent Office—and it continued for thirty years. Throughout the nineteenth century, American inventors were required by U.S. patent law to submit scale models of their creations for public display. A grand building was needed to serve as a showcase for American genius, or in the words of Congress, as a "national museum of the arts." By the 1850s, the Patent Office was filled with glass cases containing brass patent models, as well as curiosities like skulls, presidential memorabilia and portraits of Indian chiefs. During the Civil War, the Patent Office became a hospital for wounded soldiers. Walt Whitman and Clara Barton were among the volunteers who comforted the sick and

74

dying men. In March 1865, the Patent Office hosted President Lincoln's second inaugural ball. After the Civil War, patent model cases were removed and the building's grand spaces were partitioned as offices for government clerks. Congress suggested razing the old building in 1953, but preservationists persuaded President Eisenhower to intervene. The building was transferred to the Smithsonian Institution, which uses it for the American Art Museum and National Portrait Gallery. The Old Patent Office building was described by one architectural critic as a place where "works of art [are] displayed in a work of art."

2. Surratt House
(604 H Street, NW)

One of the few pre–Civil War houses remaining in Chinatown was built in 1844 for Hugh Sweeny, a bank clerk. Fifteen years later, he sold the building to W.H. Surratt, a wealthy Maryland

Surratt House. *By Edward F. Fogle.*

landowner. When Surratt died in the early 1860s, his widow moved from their Maryland farm to the Washington town house, converting it into a boardinghouse. Mary Surratt was known to have Southern sympathies and was suspected of providing a refuge for Confederate supporters. One of her boarders was the famous actor John Wilkes Booth. After Booth assassinated President Lincoln, Mrs. Surratt was arrested as a conspirator. She was tried, convicted and executed; her guilt, however, is still questioned. Trial testimony indicated that Booth met with several conspirators at Surratt's boardinghouse. She may have known of Booth's unsuccessful attempt to kidnap Lincoln during the war, but she may have known nothing about an assassination plot. A plaque on the building mentions only her involvement in an abduction plot. The house was sold and used continuously as a residence until the 1930s, when it was converted for commercial use. Five other mid-nineteenth-century buildings survive nearby the Surratt House. Together they stand as a last vestige of the old downtown.

3. CHINATOWN ARCH
(7ᵀᴴ Street at H Street, NW)

A Gateway to the East was placed in the heart of Chinatown in 1986, in the form of a giant *pai-lou*, the Chinatown Friendship Archway. It is one of the largest single-span arches in the world. A series of seven elegant, golden-tiled roofs is balanced on an amazing cantilevered jigsaw puzzle of carved, painted and balanced interlocking pieces of wood. The Chinatown Arch contains 272 painted Chinese dragons; these imaginary creatures are composed of an ox head, deer horns, shrimp eyes, eagle claws, fish scales and a snake tail. Chinese arches convey the appearance of pheasants in flight. The art of the arch is based on spatial composition, the relationships between people and their surroundings, and it must satisfy the practical and aesthetic, reflecting the theories of yin and yang. By tradition, the *pai-lou* has absolutely no functional value except to make people happy,

Chinatown Arch. *By Edward F. Fogle.*

taking them back to their childhood fantasies and forward to the discovery of new worlds.

4. 6TH AND I SYNAGOGUE (6TH STREET AT I STREET, NW)

"This is not your grandfather's synagogue," exclaimed Shelton Zuckerman four years after 6th and I Synagogue was rededicated and one hundred years after the first dedication in 1908. The monthly Friday night Shabbat service begins with appetizers, wine and beer, and following the service is a kosher dinner. This nontraditional synagogue also offers cooking classes, rock concerts, lectures and comedians that attract a young, downtown Jewish crowd. The synagogue at 6th and I Streets was built as the second home for Adas Israel Congregation. By 1951, most members had moved away

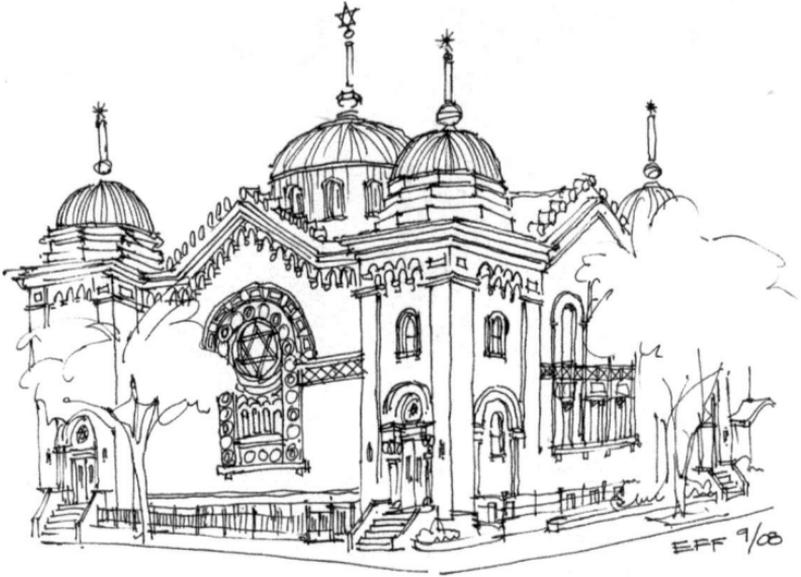

6th and I Synagogue. *By Edward F. Fogle.*

and the building was sold to Turner Memorial African Methodist Episcopal Church. Fifty years later, a nightclub owner wanted to buy the church from the dwindling Baptist congregation. Three local businessmen, Abe Polin, Doug Jemal and Shelton Zuckerman, combined forces with the Jewish Historical Society and the Greater Washington Jewish community to save and restore the synagogue. The building's architectural style was described as "eclectic revival," with its Moorish, Byzantine and Romanesque elements, decorative brickwork, multiple domes and red-tiled roof. No one quite remembered how it looked inside, until a photograph from a 1949 wedding was discovered. Among the restored details were the words that have been repainted on the walls to the sides of the Torah case: "Remember Ye the Law of Moses," and "Faith in God is Happiness."

5. Ford's Theatre
(511 10TH Street, NW)

Some people say that a curse was cast on Ford's Theatre when, in 1859, John T. Ford bought the twenty-five-year-old building that

had served as the First Baptist Church of Washington. Although the congregation had relocated to a fine new structure, several church members expressed outrage that their former sanctuary had been transformed into a laughter-filled theatre. Two years later, the building burned to the ground. Undaunted by the fire, John Ford built a new theatre on the same site. During the Civil War, it was an immensely popular place. On the evening of April 14, 1865, tragedy struck the theatre again. President Lincoln was assassinated by the famous young actor John Wilkes Booth. The theatre was immediately shuttered. Several months later, when Ford tried to reopen, he received numerous threats that the building would be set afire if ever again it was used as a place of amusement. Secretary of War Stanton ordered it permanently closed. Ford's Theatre was transferred to the government, gutted and remodeled for office use. On June 9, 1893, tragedy struck a third time. The top floor collapsed onto the two floors below, killing twenty-two office workers and injuring sixty-eight more. The War Department conveyed the building to the Office of Public Buildings and Public

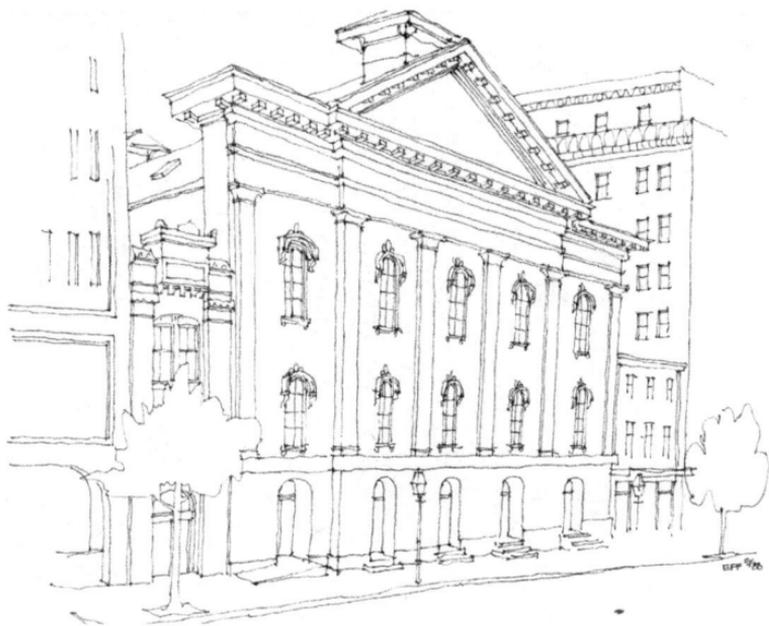

Ford's Theatre. *By Edward F. Fogle.*

Parks. A small Lincoln Museum opened in the old theatre building in 1932. Finally, in 1968, Ford's was reconstructed and restored as a working theatre and museum. The curse seems to be gone, but a reminder of the original churchgoers is to be found behind the theatre in the alley that Booth used as an escape route—it continues to be called "Baptist Alley."

6. OLD PENSION BUILDING
(440 G STREET, NW)

"A building the likes of which is not to be seen anywhere else in the country," wrote a journalist in 1887, describing the new Pension Building. Congress had requested a fireproof structure built on a tight budget. Prudently constructed of 15.5 million bricks, the Pension Building was filled with fresh air and natural light and comfortably accommodated fifteen hundred clerks, who dispensed Civil War pension benefits. The designer, General Montgomery C. Meigs, modeled the building after Rome's

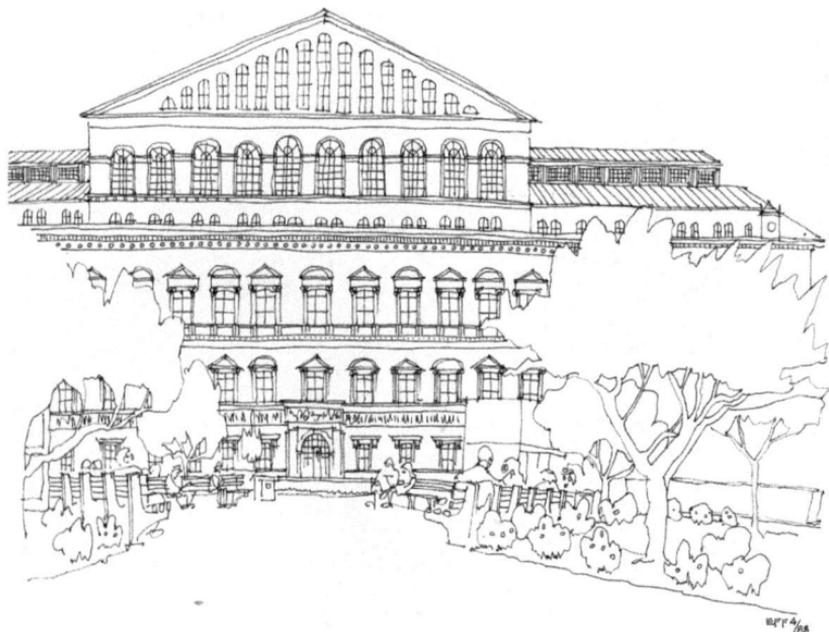

Old Pension Building. *By Edward F. Fogle.*

Palazzo Farnese but doubled the size. An extraordinary terracotta frieze parades around the building's exterior, portraying the infantry, artillery, cavalry, navy, quartermaster and medical units of the Union army forces.

The core of the building is a grand open courtyard, which architect Philip Johnson called "the most astonishing interior space in America." The world's largest Corinthian columns reach up to a sky blue ceiling. "Only a thunderstorm or an inaugural ball could fill that void," a critic noted; and in fact, inaugural balls were held in the Great Hall from 1885 to 1909. The tradition began again in 1985. Not without its critics, the Pension Building was described as "an example to our national legislators of what not to do." General Sherman, best remembered for burning Atlanta during the Civil War, is credited with exclaiming, "What a pity!" when he was told that it was fireproof. The Pension Building was used continually as a government office building until 1978. Although demolition was suggested, Congress eventually declared it a "unique historic treasure" and mandated its use as the private nonprofit National Building Museum to "commemorate and encourage the American buildings arts." It is the perfect use for such an obviously American building.

7. Masonic Lodge
(13ᵀᴴ Street at New York Avenue, NW)

A beautiful Beaux Arts structure on a triangular lot was dedicated in 1908 as "a building which by its proportions is unmistakably a temple!" Washington's Grand Masonic Lodge had carefully selected one of Washington's most sought-after architects to design its extraordinary new building. Special Masonic meeting rooms, lodge halls and offices occupied the upper stories. A fifteen-hundred-seat auditorium on the first floor was leased as a movie house beginning in 1911. After World War II, however, displays of lurid movie posters forced the Masons to close the theatre, which was reopened in 1959 as the classy Town Theatre, where white-gloved ushers escorted patrons to their seats. Unfortunately, the

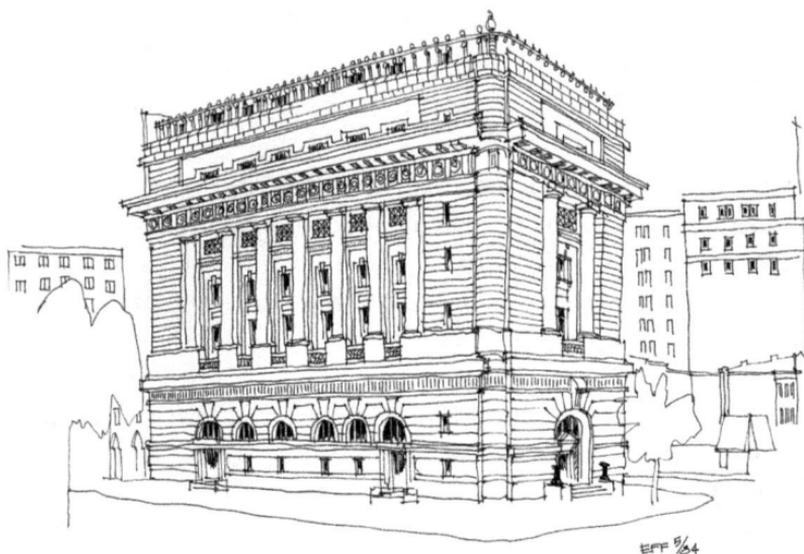

Old Masonic Lodge. *By Edward F. Fogle.*

theatre's reputation quickly declined, reflecting the decline of the surrounding neighborhood. When the Masons moved out, the building's fate was uncertain. In 1987, the "temple" was radiantly transformed. The National Museum of Women in the Arts moved in, after significant renovation. This museum was the culmination of one woman's dream. In the 1960s, Wilhelmina Holladay recognized a lack of awareness about women artists. She assembled, and then donated to the museum, her unusual compilation of art by women, including Lavinia Fontana's 1580 *Portrait of a Noblewoman*. Ironically, this former all-male bastion metamorphosed into a pink and gray, marble and gilt museum dedicated to heralding the contributions of women to the history of art.

8. Old Adas Israel Synagogue (701 3ᴿᴰ Street, NW)

Washington's first synagogue was dedicated during the celebratory year of the nation's centennial, in 1876. Just five years earlier, the

original thirty-eight members of Adas Israel had come together to establish a traditional Orthodox synagogue. The simple brick building they erected was located in the heart of the Jewish community, at 6th and G Streets, NW. Eastern European Jewish immigrants, who came to Washington in the late nineteenth century, embraced this congregation. By 1908, the membership outgrew the old building and moved to a new synagogue at 6th and I Streets, NW. The Old Adas Israel building was sold; the first floor became a bicycle shop for a while, a barbershop, a grocery store and a barbecue carryout. The sanctuary was used by St. Sophia's Greek Orthodox Church, two evangelical churches and, finally, as warehouse space. In 1968, when the synagogue was about to be razed, Washington's Jewish community ran to its rescue. The 273-ton building was hoisted onto rollers and moved three blocks away to its current location. The synagogue was restored and a museum was established, with the assistance of local philanthropists Lillian and Albert Small. Adas Israel became known as "the Temple that Traveled."

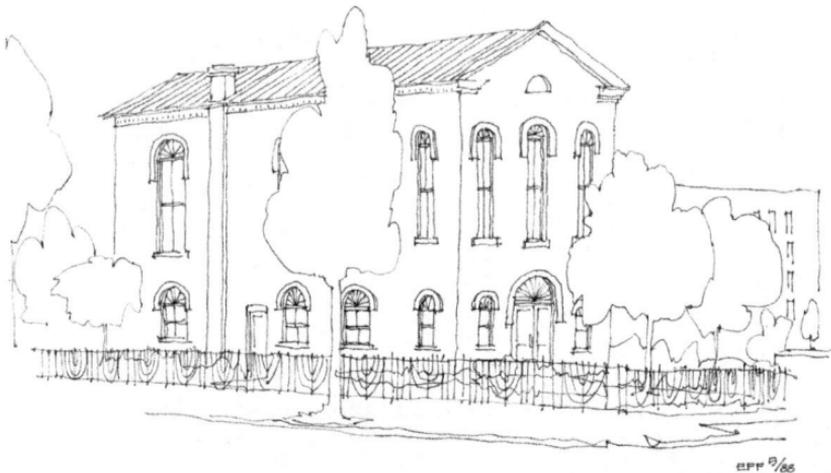

Old Adas Israel Synagogue. *By Edward F. Fogle.*

Not to Be Missed

9. Calvary Baptist Church
(8th Street at H Street, NW)

Stories abound about the red brick, American Gothic church in old downtown. First built in 1866, Calvary Baptist Church burned to the ground a year later. "The scene…was one of rare magnificence, the flames and sparks…illuminating the snow flakes, which were falling fast and thick." The church was immediately rebuilt using the same plans and crowned with a 160-foot-high iron steeple. The steeple, unfortunately, was toppled in 1913 by hurricane-force winds. The capped tower was struck by lightning in 1947, damaging both the steeple and the tower clock. The neighborhood changed, but Calvary stayed. An old photograph of the lacy steeple was found, a computer-generated image was created and the steeple was recast in aluminum and reinstalled in 2005. Calvary's popularity and its steeple are back.

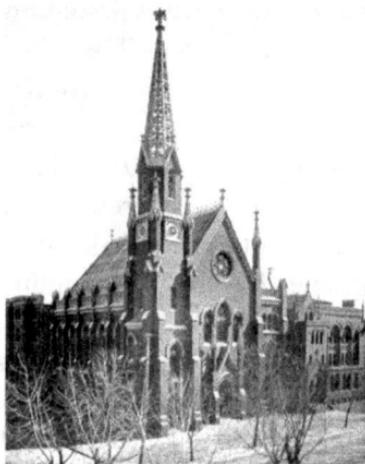

Calvary Baptist Church. *Courtesy of the Washingtoniana Division, D.C. Public Library.*

10. General Post Office
(700 F Street, NW)

"Samuel Morse, artist and inventor, opened and operated on this site…the first public telegraph office in the United States," declares the plaque on the Old General Post Office. This Roman Corinthian–style building was the first all-marble building to be erected in Washington. Occupying an entire block, it was under construction for twenty-seven years, beginning in 1839, and was

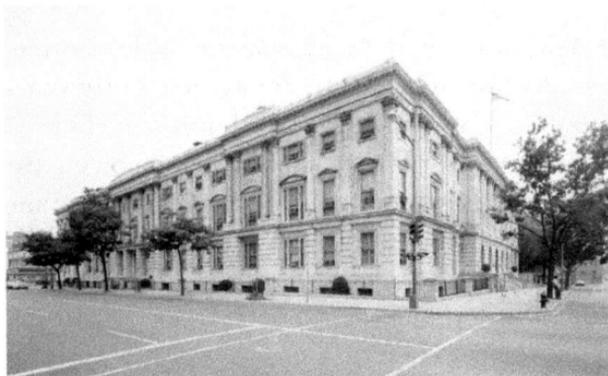

General Post Office. *Courtesy of the Library of Congress HABS/HAER/HALS.*

used as the General Post Office until 1899. From this building, in 1963, President Lincoln's postmaster general, Montgomery Blair, initiated free home mail delivery. Used for government offices until 1997, a sixty-year private lease was granted to convert the building into a luxury hotel. During the renovation, one of the most delightful design motifs was restored over the 8th Street portal. Called *Railroad and Telegraph*, two cherubs proudly hold a locomotive and a scroll to allegorically represent mid-nineteenth-century modern technology.

11. St. Mary's German Catholic Church
(723 5th Street, NW)

"A new church intended for the use of German Catholics," read the 1846 description of St. Mary Mater Dei German Catholic Church. Land for the church was donated by a non-Catholic, John Peter Van Ness, who appreciated the hardworking character of the newly arrived German immigrants and wanted to help them establish their community downtown. The present church building for St. Mary's was dedicated in 1890, and ever since Christmas Day 1920, the hour rings out for the neighborhood by the bells of St. Mary's.

12. Old Masonic Temple
(901 F Street, NW)

A grand parade accompanied the 1868 ceremonial laying of the cornerstone for the first privately built structure in Washington's

post–Civil War era. The new Masonic Temple became a symbol of renewed civic awareness and nationalism. Forty years later, the Masons moved out, and in 1920, Lansburgh's Furniture Company moved in and stayed for fifty years. In 1994, following twenty years of neglect, the temple was restored for commercial use and the hope expressed at the 1868 dedication was renewed: that the building might "endure for many ages, as a monument to the liberality and benevolence of its founders."

13. Early Commercial Buildings
(918–30 F Street, NW, and 637–41 Indiana Avenue, NW)

Washington's oldest extant commercial structures stand at 637–41 Indiana Avenue, NW. Built in the 1820s as part of the expanding business development near Center Market, these structures have survived because of preservation efforts in the 1970s by two owners: Dominick Cardella, who opened the Artefactory Shop of African and Asian Art in 1972; and Fred Litwin, who joined his father in business at Litwin's Furniture in 1951 and stayed for fifty years. The Litwin building boasts one of the oldest elevators, dating to 1854. Unfortunately, since Fred left, it is no longer operating. These two men fought and won the battle to save these treasured buildings for posterity.

With the invention of the elevator, tall buildings became practical in Washington. The Atlantic Building, built in 1888, was the largest commercial structure in the city, rising nine stories. The exterior rough-cut stone façade was deliberately designed to deemphasize the height. Sadly, only the façade of the Atlantic Building remains. The National Union Building, built in 1890, however, was carefully renovated, including the restoration of the open-cage passenger elevator. The five-story oriel windows on the building's west side face onto the alley used by John Wilkes Booth when he escaped from Ford's Theatre after shooting the president.

Dupont Circle and Kalorama Neighborhood

Washington is "the ugliest city in the whole country," complained Senator William Stewart of Nevada when he arrived in 1870. Local businessman Alexander R. Shepherd understood the problem: Washington had never been beautiful, but now it had been ravaged by four years of war. Recognizing the potential for new development, especially in the open fields to the north and west of the White House, Shepherd immediately began to make large-scale improvements. He shared his ideas with several investors, a powerful group of men from the gold-rich Wild West who became known as the Honest Miners Group. With Shepherd, they bought the land around a circle where five city streets intersected. The circle was graded, landscaped, fenced and named Pacific Circle in deference to the investors.

Senator Stewart built the first luxury mansion facing Pacific Circle in 1873. Sitting alone in the fields, it was called Stewart's Castle. The next year, Great Britain built the first foreign-owned legation nearby, and within ten years, the neighborhood had developed into the most exclusive residential area in Washington. In 1882, Congress authorized the erection of a memorial to Rear Admiral Samuel Francis Dupont, in recognition of his Civil War service, and Pacific Circle was renamed Dupont Circle. In 1921, the statue was removed and replaced by a marble fountain, with three allegorical figures holding up the basin, representing the "Arts of Navigation."

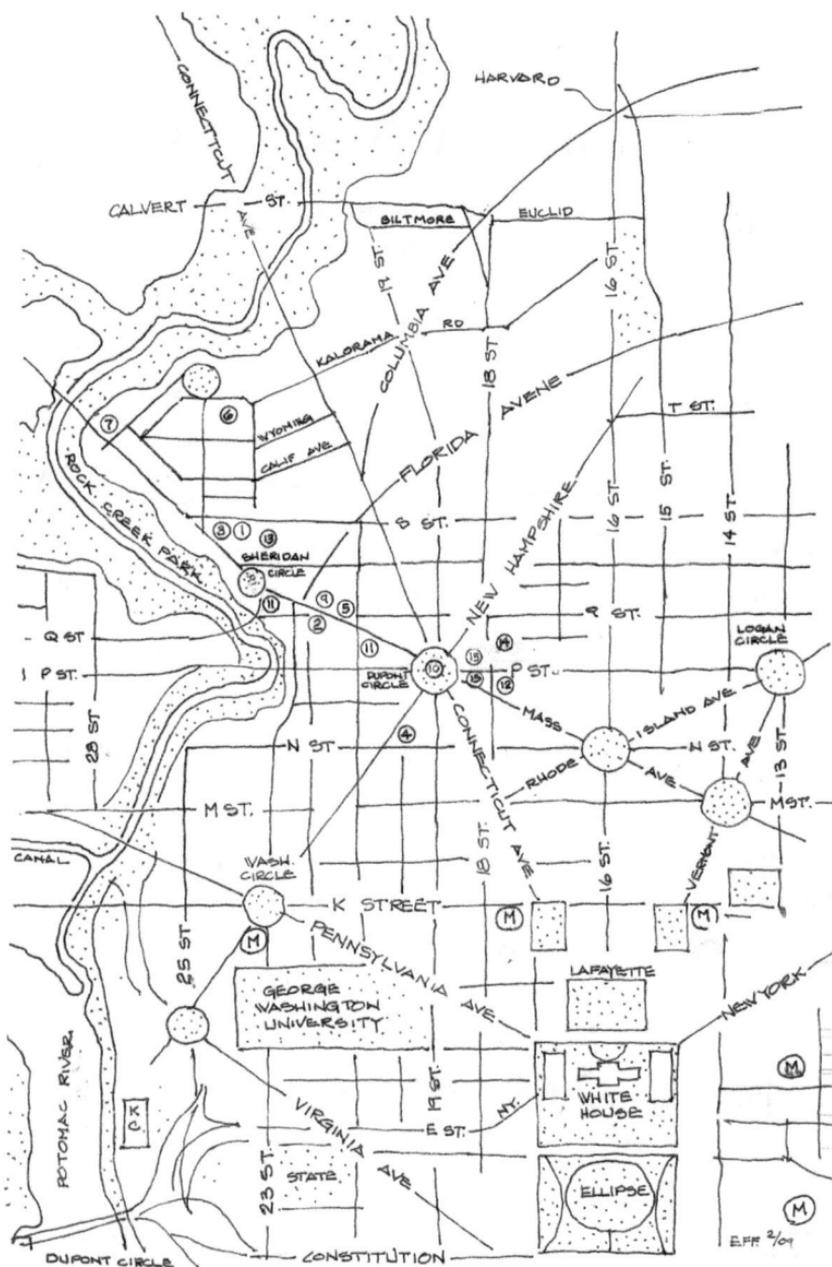

Map of Dupont Circle and the Kalorama neighborhood. *By Edward F. Fogle.*

Dupont Circle and Kalorama Neighborhood

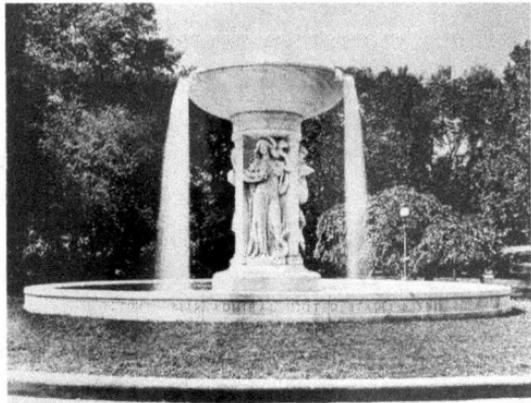

Dupont Circle Fountain.
Courtesy of the Washingtoniana Division, D.C. Public Library.

A demand for palatial residences in Washington by America's nouveaux riches caused unprecedented growth in the area. Those who had made fortunes in mining, railroads and industry came to Washington to be part of the new society. Some had been elected to serve in Congress; others, like Lars Anderson (site 2), just came for "the winter social season," during the months when Congress was in session. An expanding millionaire's colony moved farther north into an area that had once been the farm of poet and statesman Joel Barlow. In 1803, Barlow had named his property Kalorama ("beautiful view"). Ninety years later, Massachusetts Avenue was extended northward from Dupont Circle to Sheridan Circle and beyond, encouraging further growth and development. The Kalorama property was subdivided into large lots and benefited from its proximity to the wealthy of Dupont Circle. George Hewitt Myers built a home that he later transformed into the Textile Museum (site 1).

Intelligent and aggressive real estate promoters attracted wealthy new residents who wanted to live in the most fashionable part of town. This provided an opportunity for prominent, Beaux Arts–trained architects to design significant structures on carefully sited lots. Distinguished town houses were privately commissioned, Washington's largest and most expensive apartment buildings were erected and among the rich and famous there seemed to be a race to build the most fabulous and exclusive homes in the neighborhood. Five presidents, either

89

before or after their presidencies, chose to live in Kalorama, including Woodrow Wilson (site 3).

Life changed in both Dupont Circle and Kalorama during the Great Depression. Impoverished owners left and foreign dignitaries came in. Throughout the rest of the twentieth century, Dupont Circle's grand mansions either survived through transformation into embassies, office buildings and private clubs or else they were ruthlessly razed and replaced with mundane high-rise buildings. The Kalorama homes survived, although about one-third of them now belong to foreign governments. These two connected neighborhoods provide a mixture of residences with historic house museums, galleries, embassies, parks and a commercial district filled with small shops and restaurants. The remarks of a nineteenth-century writer about this area still ring true: "Fashion has firmly set its seal upon this district, and all those improvements which come with opulence have been lavished upon it."

1. Textile Museum
(2320 S Street, NW)

"Myers was blessed with a lot of money, a very good eye, and very adventurous taste," noted a New York collector about George Hewitt Myers, founder of the Textile Museum. Myers's fortune came from an inheritance left by his half brother, who co-founded Bristol Myers Pharmaceutical Company. When Myers was studying at Yale, he purchased a nineteenth-century carpet for his dorm room. His love of textiles began there and never ended. A talented financier, Myers moved to Washington, and in 1913 he built a home in Kalorama. Two years later he purchased an adjoining property for his unique textile collection, which included the finest assemblage of classical Caucasian carpets outside of Istanbul. His museum opened with 275 carpets and sixty other pieces. For thirty-two years he guided the Textile Museum, until his death in 1957. Myers left the museum with an endowment and the spirit to view textiles in a comprehensive way: through

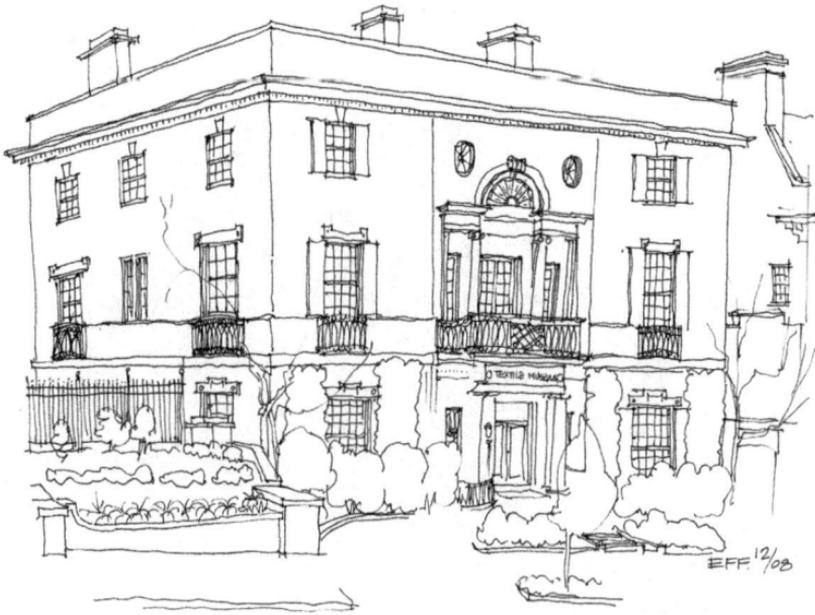

Textile Museum. *By Edward F. Fogle.*

history, archaeology, anthropology, ethnography, technology and conservation science. He collected the indigenous works that had evolved throughout time. He adored textiles that contained the vitality of personal investment; the design that comes not from the head but from the heart.

2. ANDERSON HOUSE
(2118 MASSACHUSETTS AVENUE, NW)

"The very opulent, eclectic interiors of this mansion cannot be described within the space limitation of this [report]," wrote the historians reviewing the Anderson House for placement on the National Register of Historic Places. When Larz and Isabel Anderson built their Washington winter home in 1902, with fifty rooms and forty thousand square feet of space, their intention was to leave it as the permanent headquarters for the Society of the Cincinnati, of which Larz was a member. Larz Anderson

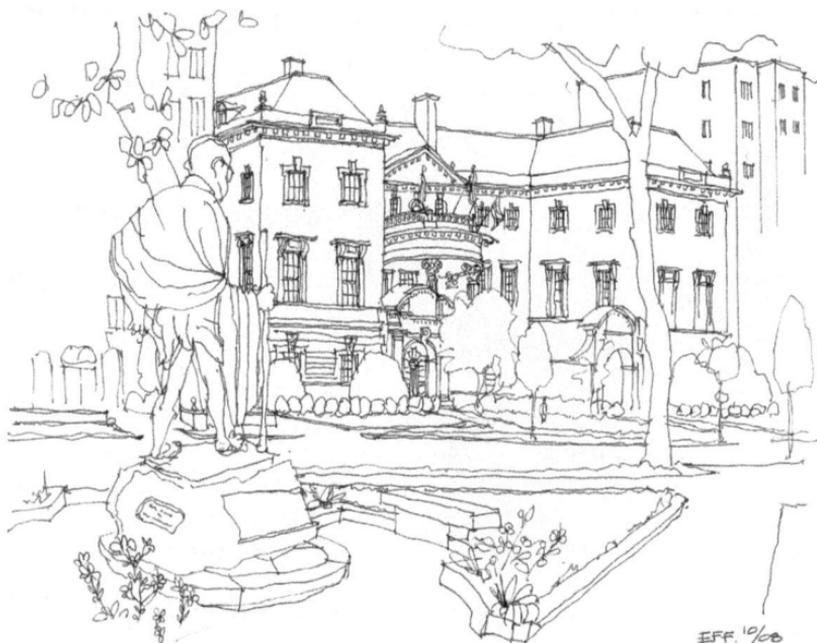

Anderson House. *By Edward F. Fogle.*

III was a career diplomat and served as minister to Belgium and ambassador to Japan. His wife, Isabel Weld Perkins Anderson, was the granddaughter of the Boston shipping magnate William Fletcher Weld. She inherited $17 million upon his death in 1881, when she was five years old. Isabel was a prolific author and Larz was an innovative artist. Together they traveled the world searching for rare and magnificent art and artifacts with which to fill their homes in Washington and Massachusetts. In 1938, the house was transferred to the Society of the Cincinnati to graciously serve as a historic house museum representative of the Gilded Age, as the headquarters of the society (an organization of first-born male descendants of Revolutionary War officers) and as a rare book library of the Revolutionary War period. There is a small irony in the fact that across the street stands the statue of the great pacifist Mahatma Gandhi.

3. Woodrow Wilson House
(2340 S Street, NW)

"I found an unpretentious, comfortable, dignified house, fitted to the needs of a gentleman's home," wrote Edith Wilson, describing the twenty-eight-room mansion to which she and the president moved directly from the White House in 1921. The Woodrow Wilson House is the only presidential museum in Washington; it is dedicated to the man who was called the hinge to the twentieth century. During his eight years as president, Wilson introduced reforms in education, banking, labor, tax issues and international relations. He implemented four constitutional amendments and created four new government departments. He reluctantly led the country into World War I and brilliantly tried to lead the world in peace efforts after the war, through his proposal for the League of Nations. Wilson lived only thirty-five months after moving into his new home; Edith stayed on until her death in 1961. She was dedicated to her husband in life and in death. Forever wanting to

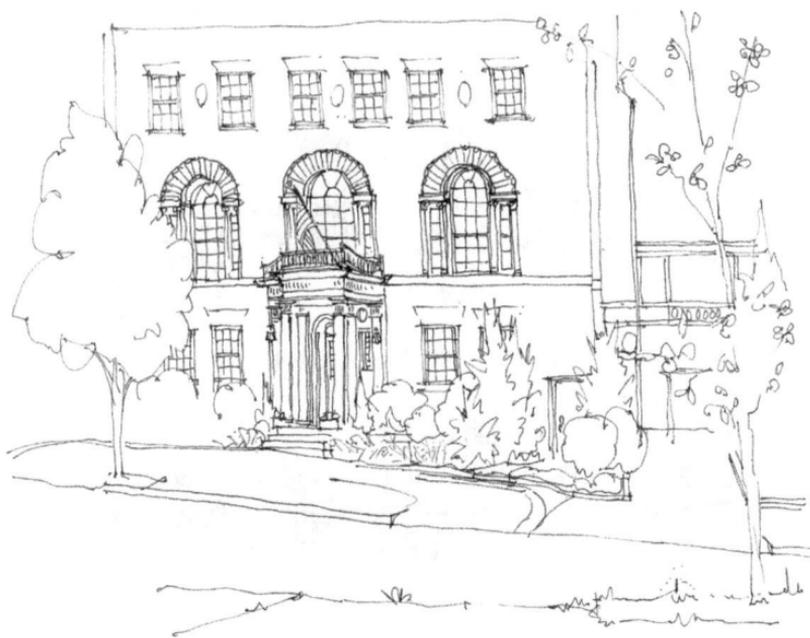

Woodrow Wilson House. *By Edward F. Fogle.*

93

preserve the public's remembrance of him, she attended dedications of memorials to his memory, entertained newly arrived first ladies in her home and saved everything that had belonged to him. In a final act to safeguard Wilson's legacy, she donated the house and its contents to the National Trust for Historic Preservation.

4. Heurich House
(1307 New Hampshire Avenue, NW)

Christian Heurich built a fortress-like Victorian mansion that served as his home for fifty years. It stands as a testimony to his

Heurich House. *By Edward F. Fogle.*

hard work, strong character and good fortune. Born in Germany, orphaned at 14 and with only a simple education, Heurich began a career in brewing that would continue for the rest of his very long life. He traveled through Europe, learning and practicing his trade. In 1866, he came to America to start a new life. Settling in Washington, he started a local brewery, sometimes working eighteen-hour days and seven-day weeks. Heurich believed in himself, in quality merchandise, in risk-taking and in luck. Proof of his success came in 1891, when he built his great brewery overlooking the Potomac River and his thirty-room residence, decorated with onyx, hand-carved wood paneling, tooled leather wall coverings and fresco-painted ceilings. Twice a widower by 1899, Heurich married for a third time. His first child was born when he was 60 years old. Prohibition shut down the brewery in 1916, but when Prohibition ended, Heurich was 90 years old and decided to start life anew. He reopened the brewery, and at age 102, he was America's oldest active brewer. Often asked about his longevity and good fortune, he would carefully reply, "Practice moderation, even in moderation…and drink Heurich beer."

5. PHILLIPS COLLECTION
(1600 21ˢᵀ STREET, NW)

Duncan Phillips grew up in Washington surrounded by art. When he attended Yale to study literature, he wrote about art, and he even started a small, personal art collection of pictures painted by his friends. Tragically, his dearly loved father and brother died within a year of each other. To honor them, Duncan Phillips dedicated two rooms in his Washington home as a memorial gallery and opened them to the public. His original collection of 240 paintings formed the nucleus of the first museum in America dedicated solely to modern art and its sources. The two rooms provided an intimate, homey atmosphere for visitors. Eventually, the collection took over the entire home. Duncan Phillips and his family moved out, but the collection remained. Each painting was carefully chosen by

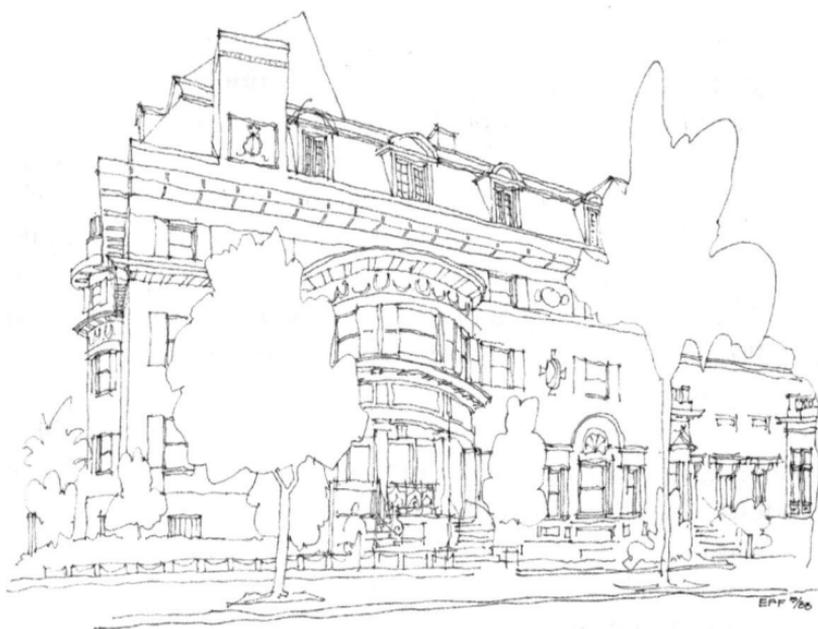

Phillips Collection. *By Edward F. Fogle.*

Phillips for its "joy-giving, life-enhancing influence" that might assist "people to see beautifully as true artists see." The joyful use of color is a unifying factor in this extraordinary one-man collection. In 1923, Phillips purchased Renoir's *Luncheon of the Boating Party*, and over time, he bought more than 2,600 works by painters whom he considered to be forever modern. The Phillips Collection has become exactly what Duncan Phillips wanted it to be: "a defense against the outer world [and] a haven for those who enjoy getting out of themselves into the land of artists' dreams."

6. THE LINDENS
(2401 KALORAMA ROAD, NW)

The three-story residence called the Lindens sits on one of the largest lots in Kalorama. It is one of the most expensive homes, and the oldest, in Washington, but it wasn't built here. Robert "King" Hooper, a Massachusetts shipbuilder, commissioned the

ornate summer home in 1754. A British supporter during the Revolutionary War, Hooper loaned his house in 1774 to the hated British general Thomas Gage, the last colonial governor of Massachusetts. The Lindens had many owners, but the owners who bought it in 1933 began to strip and sell the room interiors to museums. George and Miriam Morris came to the rescue when they purchased it, and over a period of three years, the house was carefully dismantled, shipped to Washington and painstakingly reassembled. It became a showplace for Mrs. Morris's collection of antique Georgian furniture. In the 1950s, a historian noted, "One may quite properly regard The Lindens as an acceptably adopted member of the family of historic houses in Washington."

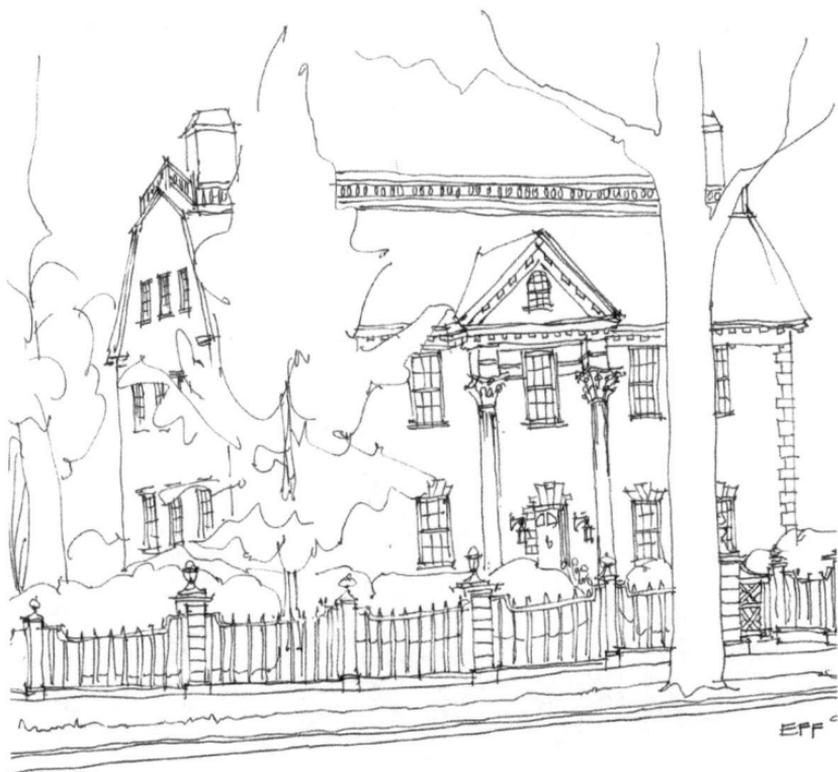

The Lindens. *By Edward F. Fogle.*

7. ISLAMIC CENTER AND ISLAMIC MOSQUE
(2551 MASSACHUSETTS AVENUE, NW)

Shortly after World War II, land was purchased for the Islamic Center, and an Italian architectural professor, Mario Rossi, was hired to design the Moorish structure, which was completed in 1956. While the façade of the Islamic Center parallels Massachusetts Avenue, the inner mosque is squared off to be in line with the great circle direction of Mecca, causing the 160-foot minaret tower to appear slightly askew. The center serves a national function for Muslims in America by publishing an annual calendar for the guidance of worshipers, in addition to offering religious training and religious ceremonies. The call to prayer is given five times a day from a loudspeaker atop the minaret tower. Inside the mosque, worshipers are surrounded by walls covered with Turkish painted tiles; an Egyptian nickel and brass chandelier hangs from the ceiling; and on the floors are Persian carpets, a gift from the former shah of Iran.

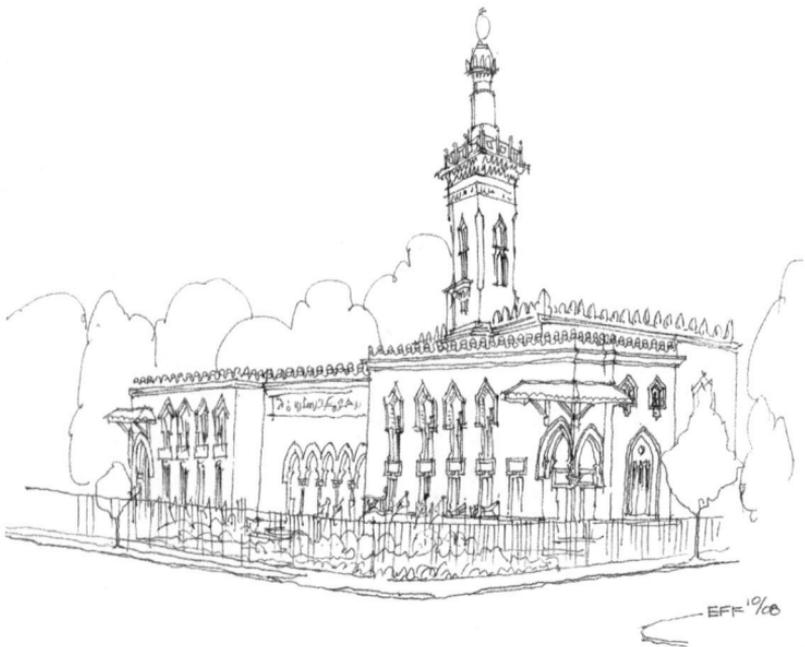

Islamic Mosque. *By Edward F. Fogle.*

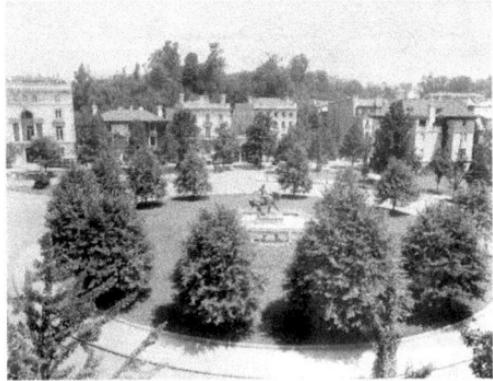

Sheridan Circle. *Courtesy of the Star Collection, D.C. Public Library.*

Not to Be Missed

8. Sheridan Circle

Sheridan Circle is the perfect example of what an ideal Washington circle should be. With radiating avenues surrounded by handsome homes, the small formal park features one of the finest equestrian statues in the city. Sculpted by Gutzon Borglum, who later carved Mt. Rushmore, the statue was deliberately not put up high on a pedestal. General Sheridan gestures from his horse, Rienzi, which carried him through eighty-five battles and was renamed Winchester. Mrs. Sheridan lived near the circle and chose the site for the memorial because she could view it from the upper balcony of her home.

9. Townsend Mansion
(2121 Massachusetts Avenue, NW)

Richard and Mary Townsend built their mansion in 1901, "in the style of the Petit Trianon" at Versailles. The new home incorporated parts of an existing home, because Mary was superstitious and believed that "she would encounter evil if she were to live in a totally new house." Townsend's fortune came from Pittsburgh; his daughter, Mathilde, was called the richest girl in Washington. She married Sumner Wells, Franklin D. Roosevelt's under secretary of state. When Mathilde died in 1949, Wells sold the house to the Cosmos Club, whose membership was open to

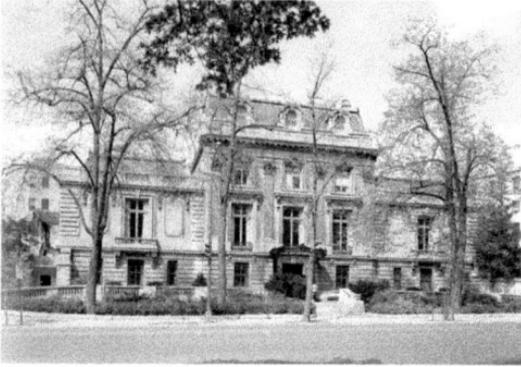

Townsend Mansion.
Courtesy of the Library of Congress HABS/HAER/HALS.

distinguished men in the fields of science, literature and the fine arts (in 1972, membership was opened to women). The club was once described as "the closest thing to a social headquarters for Washington's intellectual elite."

10. Dupont Circle

From an open spot where three avenues and two streets intersect, a formal park was created in 1871. Originally, a grand central fountain was to be erected in the park, but in 1882 Congress authorized a statue to memorialize Admiral Samuel Francis Dupont, the first naval hero of the Civil War. Unfortunately, the admiral was more often remembered for his defeats than his victories, and the Dupont family had the statue removed. They replaced it with a beautiful marble fountain designed by Daniel Chester French, with three allegorical figures representing the Wind, a male figure wrapped in a billowing sail; the Stars, a female figure holding a globe; and the Seas, another female figure embracing a ship and a gull, with dolphins playing at her feet.

11. Walsh-McLean Mansion
(2020 Massachusetts Avenue, NW)

"Daughter, I've struck it rich!" exclaimed Tom Walsh, a poor Irish immigrant, to his young daughter, Evelyn. He had discovered gold in Colorado. Five years later, Tom Walsh built a sixty-room

mansion in Washington, at a cost of $835,000. "It is a palace that expresses dreams my father and mother had when they were poor in Colorado," wrote Evelyn years later. With more money than she could spend, Evelyn and her husband, Ned McLean, purchased the Hope Diamond in 1911. Upon her death, the Hope was sold and was later donated to the Smithsonian Institution. The residence was purchased by Indonesia and has been its embassy in Washington since 1952.

12. McCormick Apartment Building
(1785 Massachusetts Avenue, NW)

The finest apartment house in Washington was the McCormick, built in 1916. Secretary of the Treasury Andrew W. Mellon occupied the entire top floor of the building: an eleven-thousand-square-foot apartment. He had an exceptionally fine assemblage of Old Masters' paintings on display, which he later donated to form the nucleus of the collection for Washington's National Gallery of Art. In 1950, the McCormick became an office and storage building before being rescued in 1977 by the National Trust for Historic Preservation, which restored it to serve as its headquarters.

13. Spanish Steps
(22nd Street at Decatur Place, NW)

"An unusually happy example of city planning gone absolutely right," wrote an author about the Decatur Terrace Steps. In 1911, the steep rise of 22nd Street between Decatur Terrace and S Street, NW, was considered impassable for vehicles. D.C.'s Office of Buildings and Grounds decided that it should become a pedestrian passageway. An enchanting curved set of steps, with a fountain, lampposts, trees and plantings, was constructed. The neighborhood has adopted the little park and renamed it Washington's Spanish Steps, comparing it, in an imaginative way, to Rome's grand Piazza di Spagna.

14. St. Thomas's Episcopal Church
(18th Street, Between P and Q Streets, NW)

A handsome gray granite English Gothic church stood on the corner of 18th and Church Streets, NW, from 1899 until 1970. The sanctuary accommodated 850 worshipers. Franklin Roosevelt attended services at St. Thomas's when he lived in the neighborhood from 1913 to 1920. In August 1970, burglars ransacked the church and set it on fire. The blaze was intense and uncontrollable. The congregation decided not to rebuild but rather to stabilize the only surviving east chancel wall and create a park on the site, open to the sky and open to the neighborhood.

15. Ladies Clubs
(1801 Massachusetts Avenue, NW, and 15 Dupont Circle)

The Wadsworth House is shaped like a boat, with its prow facing Dupont Circle and its entry on Massachusetts Avenue. Built in 1900, a carriage driveway cut through the middle of the house to shelter guests arriving for a party in the second-floor ballroom. In 1932, Miss Mable Boardman, a neighbor and former head of the Red Cross, organized a group of ladies to purchase the Wadsworth House for use by the Sulgrave Club, named to honor George Washington's ancestral home in England, Sulgrave Manor.

Cissy Patterson lived in the grand white home facing Dupont Circle that was built by her mother in 1903. Her family owned newspapers, and in the 1930s, Cissy bought the *Washington Herald* and the *Washington Times*, combining them into Washington's only around-the-clock newspaper. By the 1940s, she was considered to be one of the most powerful women in the country and was referred to as both a street fighter and a grande dame. After she died in 1948, her house was purchased by a group of ladies for the Washington Club, formed in 1891 for literary purposes and for mutual improvement.

Foggy Bottom Neighborhood

J acob Funk, a German immigrant, bought and subdivided the bottomland along the Potomac River before the Revolutionary War, hoping to develop it into a prosperous port city like Georgetown. Named "Hamburg," often called "Funkstown," it was only a town on paper when Congress arrived in 1790. In the early 1800s, an odd mix of rural, urban, commercial and waterfront lifestyles came to Funkstown, later called Foggy Bottom. Wharves were built into the Potomac and warehouses were erected. In 1807, a glass-blowing factory opened, with skilled Bohemian workmen making glass that was "of a very superior quality."

Thomas Jefferson favored the hill in Funkstown for the placement of the Capitol. George Washington disagreed. The hill was named Camp Hill when the marines camped there in 1801, before the Marine Barracks were established on Capitol Hill. The Naval Observatory, the government's first major scientific establishment, was built in 1844 on Camp Hill, later called Observatory Hill. An American Meridian was established in 1849 that ran through the dome of the observatory. It was used by surveyors mapping the western territories before the Greenwich Meridian became the standard. The Utah-Nevada border is thirty-six degrees west of 24th Street. Fog rising from the bottomland forced the relocation of the observatory to higher ground and probably was the origin of the name Foggy Bottom.

SHERIDAN CIRCLE

DUPONT CIRCLE

LOGAN CIRCLE

R ST.

P ST.

31 ST.

25 ST.

N ST.

MASSACHUSETTS

ISLAND AVE

SCOTT CIRCLE

RHODE

13 ST.

M ST.

CONNECTICUT AVE

M ST.

16 ST.

VERMONT AVE

K ST.

K ST.

NEW HAMPSHIRE

25 ST.

NEW

PENNSYLVANIA AVE

EYE

H ST.

LAFAYETTE

GEORGE WASHINGTON UNIVERSITY

G ST.

19 ST.

18 ST.

VIRGINIA AVE

E ST.

WHITE HOUSE

23 ST.

STATE

T

ELLIPSE

FEDERAL TRIANGLE

CONSTITUTION AVE

NATIONAL MALL

14 ST.

REFLECTING POOL

MEMORIAL BR.

TIDAL BASIN

POTOMAC RIVER

PENTAGON LAGOON

FOGGY BOTTOM

EFF 2/09.

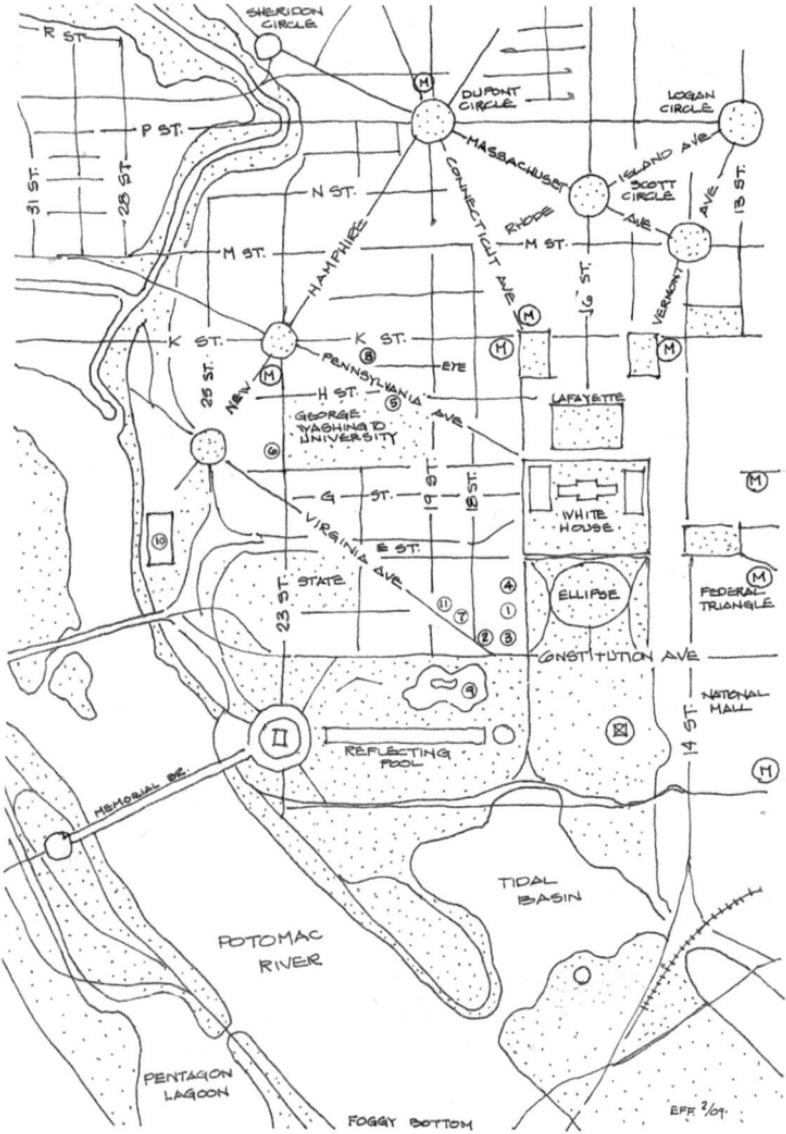

Map of the Foggy Bottom neighborhood. *By Edward F. Fogle.*

Foggy Bottom Neighborhood

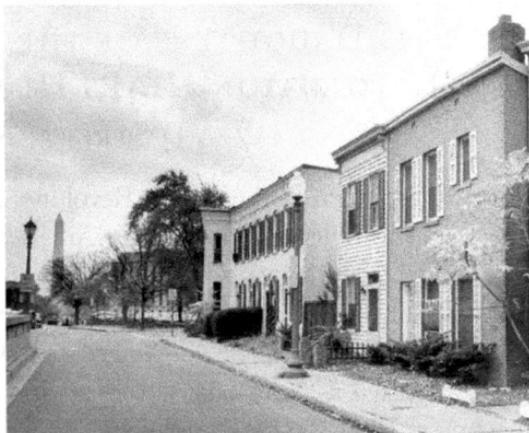

Row houses on Virginia Avenue, NW, Foggy Bottom. *Courtesy of the Library of Congress HABS/HAER/HALS.*

In the 1830s, laborers settled in Foggy Bottom to help build the C&O Canal. By the 1840s, a shipyard, icehouses, lime kilns and the Washington Gas Light Company were established in Foggy Bottom. Newly arrived Irish immigrants worked at the gasworks; the German immigrants worked in the Foggy Bottom breweries. African American laborers also settled in Foggy Bottom and built the beautiful St. Mary's Episcopal Church (site 6). Long blocks of flat-front, two-story row houses were built for the Foggy Bottom working-class residents. The demand for cheap housing led to the construction of the city's first alley dwellings. The squalid, overcrowded conditions in the alleys continued for more than fifty years.

The quaint row houses disappeared as development took hold in Foggy Bottom. George Washington University moved to the area in 1910; the campus now covers more than twenty blocks. The State Department and Interior Department (site 7) moved to Foggy Bottom. Impressive Beaux Arts–style buildings were erected on 17th Street, NW, for the Red Cross (site 4) and the Organization of American States (OAS) (site 3). By the 1970s, the gas tanks and brewery were replaced by the Watergate Complex and Kennedy Center (site 10). Foggy Bottom, once a working-class community, became a neighborhood that is very much in demand.

1. Daughters of the American Revolution (DAR) Headquarters
(1776 D Street, NW)

"But were there no mothers of the Revolution?" asked Mary Lockwood, after hearing that the Sons of the American Revolution had voted to exclude women from its membership in 1890. Mrs. Lockwood, a descendant of a Revolutionary War veteran, led the movement to establish the Daughters of the American Revolution. The aims of the DAR are listed as "patriotic, historical, and educational." At the first meeting in 1890, the DAR members decided that a memorial building should be erected in Washington to house historical relics. In 1910, they dedicated the Beaux Arts–style building as their headquarters, with the original entry on the south portico and its thirteen columns representing the original thirteen states. By 1920, the membership had grown, and a new convention hall was added, accommodating nearly 4,000 people. Before the Kennedy Center was built, the National Symphony Orchestra preformed regularly at "Constitution Hall." The DAR membership of 200,000 women administers and maintains the largest group of buildings in the world owned exclusively by women.

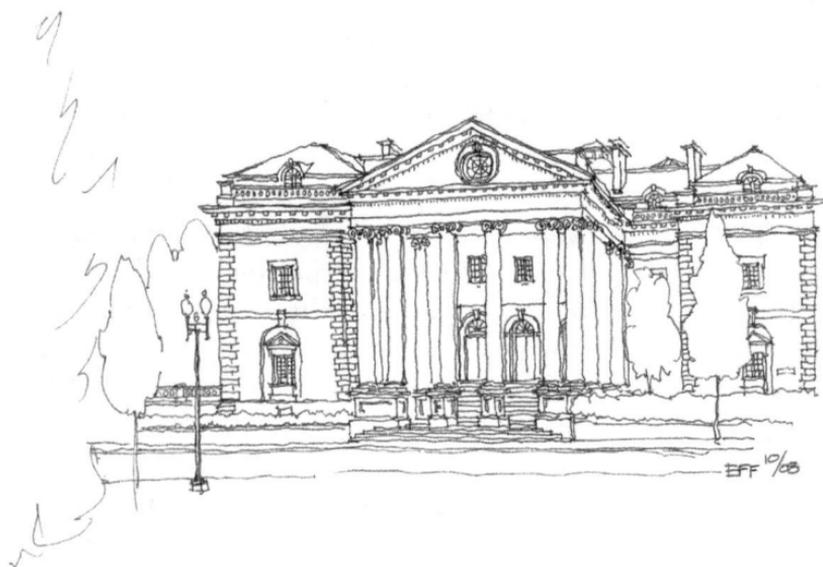

Daughters of the American Revolution headquarters. *By Edward F. Fogle.*

Art Museum of the Americas. *By Edward F. Fogle.*

2. ART MUSEUM OF THE AMERICAS
(201 18ᵀᴴ STREET, NW)

The Aztec Gardens, its pool lined with brilliant turquoise tiles, stretches between the OAS headquarters and the OAS Annex building. Presiding over the pool is Xochipili, the Aztec god of flowers. The Annex, once the private residence for the OAS directors general, today houses the Art Museum of the Americas. Built in 1912 to resemble a Spanish villa, its loggia is decorated with colorful clay tiles representing Aztec and Inca legends. Established in 1976, the museum has given many Latin American artists their first opportunity to display their work internationally. Artwork purchased from the shows have formed the nucleus of the museum's permanent collection.

Organization of American States. *By Edward F. Fogle.*

3. ORGANIZATION OF AMERICAN STATES (OAS)
(17TH STREET AT CONSTITUTION AVENUE, NW)

North American and South American ideals come together in the architecture and ornamentation of the OAS Building. Designed in 1910, the Beaux Arts building speaks for itself, with Aztec, Incan, Mayan and Toltec motifs carved into the decorative marble coursing. On either side of the entrance are statues that allegorically represent North and South America. Above the statues are carved panels, one portraying George Washington and his generals and the other, Simón Bolívar and José de San Martin. The OAS was founded in 1889 during the first International Conference of American Republics. Andrew Carnegie, a participant at the conference, later funded the construction of the OAS building. The purposes of the OAS include strengthening peace and promoting economic, social and cultural development among the thirty-five member countries. Several modern sculptures are on the grounds surrounding the building, including a bas-relief of Rubén Dario, the Nicaraguan poet, and a bust of Cordell Hull, Franklin D. Roosevelt's secretary of state, known for his "Good Neighbor" policy with Latin America.

4. American Red Cross
(17ᵀᴴ Street, Between D and E Streets, NW)

Inscribed on the statue of Jane Delano is a quote from the Ninety-first Psalm: "Thou shalt not be afraid for the terror by night; not for the arrow that flieth by day." Delano, founder of Red Cross Nursing Services, was one of 296 Red Cross nurses who died in service during World War I. Her statue, and another sculpture dedicated to and entitled *The Red Cross Men and Women Killed in Service*, stands in a courtyard surrounded by three Red Cross buildings. The main building serves as the national headquarters for the largest volunteer organization in the United States. Chartered in 1881, the organization's funding comes totally from private contributions, and the workforce is primarily volunteers. Clara Barton founded and presided over the American Red Cross until 1912. Her successor, Mabel Boardman, helped raise the funds for the main building, which was dedicated in 1817 as a monument "To the Women of the North and To the Women of the South."

American Red Cross. *By Edward F. Fogle.*

Red Lion Row. *By Edward F. Fogle.*

5. Red Lion Row
(2000 Pennsylvania Avenue, NW)

Red Lion Row is one of the only city blocks that retains a relatively uninterrupted nineteenth-century street façade. This old commercial row, named for a long-gone tavern, represents seventy years of architectural styles. These buildings were used mainly for commercial purposes until they were purchased by George Washington University for redevelopment. Neighborhood residents began to call the university "the thing that ate Foggy Bottom" as they watched block after block of row houses disappear, only to be replaced with massive, modern structures. A ten-year battle to save Red Lion Row ended with a compromise. Red Lion Row's old buildings were gutted, their façades propped up and connected to a glass-ceilinged corridor that attaches to a looming, ribbon-windowed office building. The result has been called a casebook example of what not to do. However, one critic more pragmatically stated that half a loaf is better than none.

6. St. Mary's Episcopal Church
(730 23ʳᵈ Street, NW)

A replica of an English village church was designed by architect James Renwick in 1887 for the first African American Episcopalian congregation in Washington. Secretary of War Edwin Stanton supported the congregation by providing a temporary place of worship. Renwick designed the church to be entered from a cloister-like courtyard. The pews are hand-carved oak, the walls are covered in polychrome stencil work, the floors are of encaustic tiles and even the radiators have decorative quatrefoil molds. Two of the stained-glass windows were created by Lorin of Chartres, one of which is dedicated to Abraham Lincoln. Another stunning window, by Tiffany, is dedicated to Edwin Stanton. St. Mary's has been described as "an ecclesiastical, architectural, and social artifact...a relic of urban felicity in the nondescript landscape of Foggy Bottom."

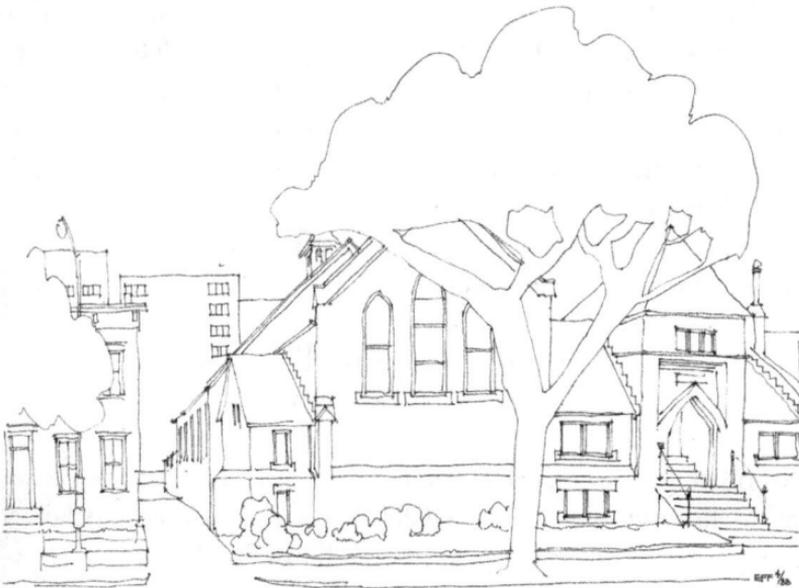

St. Mary's Episcopal Church. *By Edward F. Fogle.*

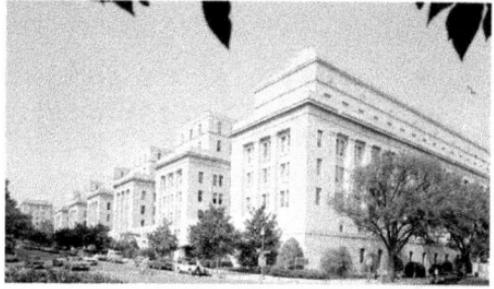

Department of the Interior.
*Courtesy of the Library of
Congress HABS/HAER/HALS.*

NOT TO BE MISSED

7. Department of the Interior
(1849 C Street, NW)

"The Department of Everything Else" was the title applied to the Department of the Interior. Unlike other departments, it lacks one main theme, like "Treasury." The Interior Department was created in 1849 and has included such varied bureaus as Patents, Pensions, Agriculture, Forestry and Indian Affairs, only a few of which are still part of the department. In 1916, its most visible entity was established, the National Park Service. In 1936, the Interior Department moved into a modern, Art Deco–style building, with a cafeteria for four thousand, twenty-four elevators and central air conditioning. Huge murals were painted throughout the building depicting historical themes and the work of the individual bureaus. The building has two hidden gems: a museum displaying an exceptional collection of artifacts and the Indian Craft Shop established to encourage the ongoing creation of indigenous art.

8. Timothy Caldwell House
(2017 I Street, NW)

"No other organization has headquarters with a more conspicuous link to history, than the Arts Club," a society writer proclaimed. Timothy Caldwell built his handsome house in 1805, and the Arts Club purchased it more than one hundred years later. James Monroe leased it from 1811 to 1817 while serving as secretary of state, and he

remained in the house for six months after his inauguration, while repairs were completed on the White House. In the 1820s, Stanford Canning, the British minister, leased the house. He is best remembered for having arrived at a White House party lying on his back in a hearse. His carriage had broken down and no other vehicles were available. He emerged, headfirst, dressed in full diplomatic regalia, perfectly composed and on time; after the party, he returned home to the Caldwell House the same way.

Timothy Caldwell House.
Courtesy of the Library of Congress HABS/HAER/HALS.

9. Constitution Gardens
(South of Constitution Avenue, Between 17th and 22nd Streets, NW)

Temporary World War I munitions buildings lined Constitution Avenue for fifty years, inspiring the comment: "The only things permanent in Washington are those old Tempos." In 1976, Constitution Gardens replaced them. This landscaped park has a pond with an island that serves as a memorial to the signers of the Declaration of Independence. As a reminder of the sacrifices of our founding fathers, the last sentence of the Declaration is inscribed at the memorial's entry: "And for the support of the Declaration, with a firm reliance on the protection of divine Providence, we mutually pledge to each other our Lives, our Fortunes, and our sacred Honor."

10. Kennedy Center and Watergate
(Virginia Avenue at New Hampshire Avenue, NW)

In the late 1960s, a luxury high-rise community was built next to where a new cultural center was to be erected. Named for the nearby Water Gate Steps, the Watergate is called the second best–known address in Washington because of the scandal that led to President

Nixon's resignation in 1974. Creating a National Cultural Center in Washington was fervently pushed by President Kennedy. In 1971, the Kennedy Center was dedicated as a living memorial to President Kennedy, as was Washington's Performing Arts Center. "I am certain," Kennedy said in 1962, "that after the dust of centuries has passed over our cities, we, too, will be remembered not for our victories or defeats in battles or in politics, but for our contribution to the human spirit."

11. Hispanic Heroes Memorials
(Virginia Avenue, Between 18th and 24th Streets, NW)

Personifying the spirit of independence, five monuments honoring courageous Hispanic leaders and international friendships occupy places of honor in several small parks between the OAS building and the Kennedy Center.

José Artigas, the father of Uruguay's independence, led the Gauchos Revolt in 1811. He was known to carry a copy of the U.S. Constitution with him at all times. The "Gaucho Statue" was a gift of Uruguay in 1950. Simón Bolívar, the great liberator, devoted his life to the cause of South American independence. He led more than two hundred battles, winning freedom for Bolivia, Colombia, Ecuador, Peru and Venezuela. The equestrian statue was donated in 1959 by Venezuela. José de San Martin, a soldier and statesman, fought for the freedom of Argentina. He also led a daring twenty-four-day march over the Andes to liberate Chile. Argentina gave the equestrian statue of San Martin in 1925. Bernardo de Gálvez, a Spanish colonial leader, supplied arms to the colonists during the Revolutionary War and forced the British from West Florida in 1781. King Juan Carlos of Spain gave the equestrian statue in 1976. Benito Pablo Juárez, the father of modern Mexico, was a revolutionary leader who became president of Mexico. He fought for the rights of the common citizen. The gesturing statue was a gift of Mexico in 1969.

Mt. Pleasant, Meridian Hill and Adams Morgan Neighborhoods

Washington's first suburb was Mt. Pleasant, developed in the late 1860s on the heights north of the White House. Columbian College, later renamed George Washington University, built its first building on the heights, known as Meridian Hill, in 1820. Taken over during the Civil War by the Union army, the college was used as a military camp. Following the war, real estate speculators, recognizing the beauty and advantages of these heights, quickly purchased, subdivided and marketed Mt. Pleasant.

Ingleside (site 2), built in the 1850s, was the first significant residence in Mt. Pleasant, situated on a 140-acre estate. Fifteen years later, government clerks seeking a more idyllic lifestyle purchased property in Mt. Pleasant and started a new community. Separated from the city, they erected their own social hall for spiritual gatherings and temperance meetings; they raised poultry, kept cows and tended backyard vegetable gardens. An omnibus company was organized by 1871, marking the beginning of the Mt. Pleasant streetcar line and allowing city dwellers easy access to Mt. Pleasant. Rows of carefully sited, skillfully designed houses were erected, following the contours of the curving hillside. The aesthetically pleasing row houses featured front porches and rhythmic rooflines. In the early 1900s, some of the city's first and finest apartment buildings were constructed in Mt. Pleasant. A commercial corridor developed, and in 1925 the Mt. Pleasant Library was opened (site 3).

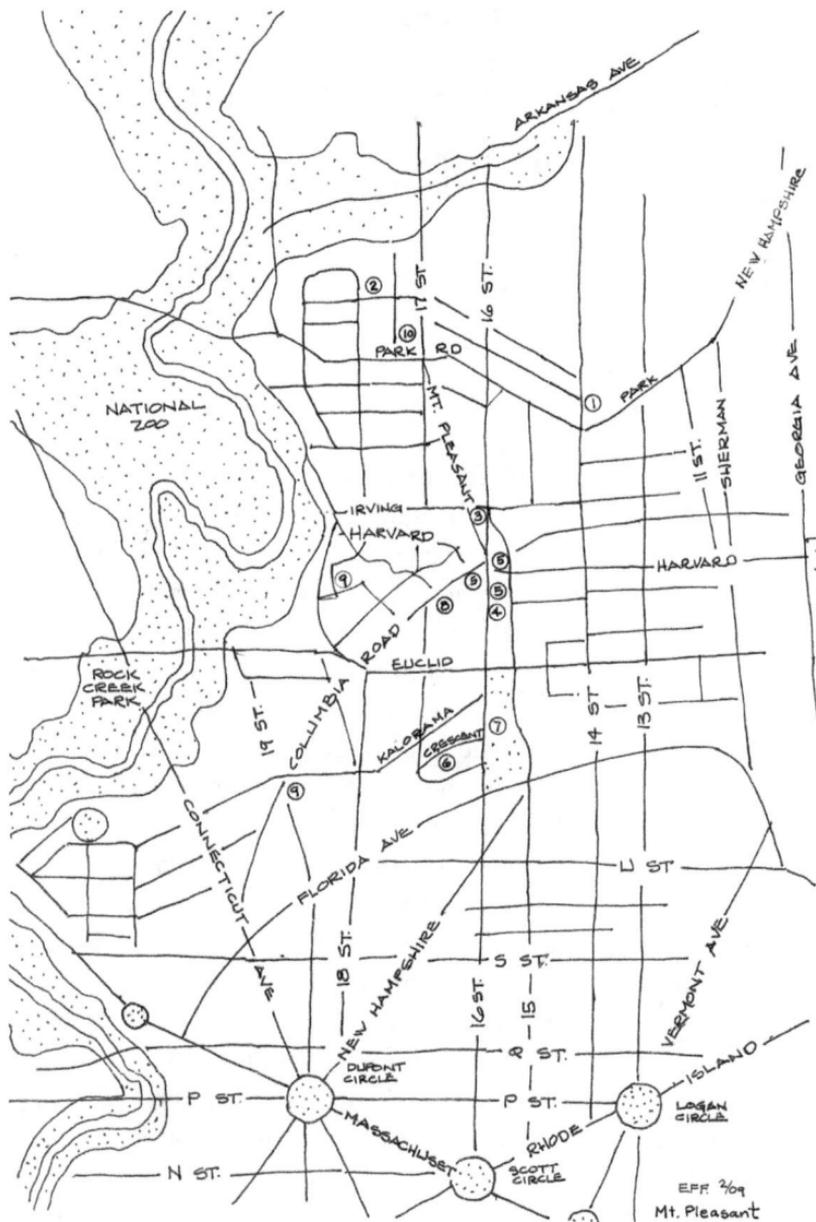

Map of Mt. Pleasant, Meridian Hill and Adams Morgan neighborhoods. *By Edward F. Fogle.*

Mt. Pleasant, Meridian Hill and Adams Morgan

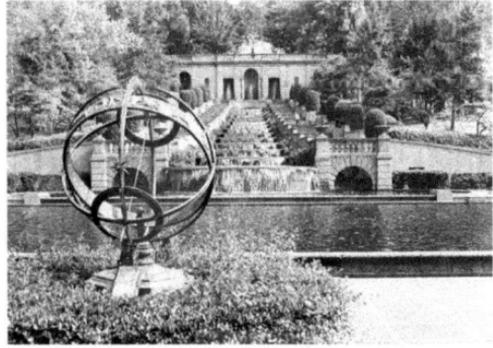

Meridian Hill Fountain. *Courtesy of the Washingtoniana Division, D.C. Public Library.*

In 1889, "Henderson Castle" was erected for Mary and John Henderson on Meridian Hill. Mrs. Henderson was a wealthy, powerful, forward-thinking woman who wanted to create an elite community around her "castle." She purchased three hundred property lots and hired a prominent architect to build residences for foreign ambassadors and even one for the vice president, though he never lived there. Mary Henderson bullied Congress into changing the name of 16th Street to Avenue of the Presidents. Congress voted to change it back when she was out of town. Mrs. Henderson convinced Congress to develop the twelve acres of land that she owned on Meridian Hill into a magnificent, European-style park. For years, the summer evening concerts drew large crowds to Meridian Hill Park. Embellished with a magnificent, cascading Italianate fountain and grand French-inspired promenades, the park also showcases some unusual statuary: Joan of Arc, Dante Alighieri and President James Buchanan (site 7).

Lanier Heights (later renamed Adams Morgan) was developed in the early 1900s. Luxury apartment buildings (site 9) and fine row houses were popular with Washington's upper middle class, including dignitaries, politicians, socialites and presidents. Expensive stores and caterers dominated the commercial corridor, and three extraordinary churches (site 5) crown one of the highest sites in the city. After World War II, the area changed. Lanier Heights became known as Adams Morgan, named for two segregated elementary schools, the Adams School and the Morgan School. The African American parents and white parents banded together for better schools for all. They integrated their schools and proudly called the neighborhood Adams Morgan. Hispanic, African and Asian immigrants settled in the

neighborhood, and by the 1970s, young professionals also moved in. The wide variety of residents adopted a motto for their neighborhood: "Adams Morgan—Unity in Diversity."

1. TIVOLI THEATRE
(14TH STREET AT PARK ROAD, NW)

Harry Crandall, a major Washington movie house operator, built the Tivoli in 1924 as a four-story Italian Renaissance silent movie palace seating twenty-five hundred people. The opening day orchestra performance was given by Fred Waring's Pennsylvanians. By 1928, the Tivoli was equipped for sound, with Vitaphone and Movietone, and presented the first movie with sound, *The Jazz Singer*. Twenty years later, the neighborhood had changed and the more affluent residents moved away. During the 1968 riots, hundreds of nearby businesses were destroyed, but the Tivoli survived and continued to operate until 1975. For thirty years, the preservationists struggled to protect the abandoned Tivoli Theatre. Success finally came in 2005, when the building was renovated and reopened as retail, office and a small performance space for the GALA Hispanic Theatre. The exterior walls that are covered in pebble-dash stucco have been restored, along with the arched windows, decorative bracketing and tile roof. The Tivoli, once again, is the centerpiece of a vibrant, expanding neighborhood.

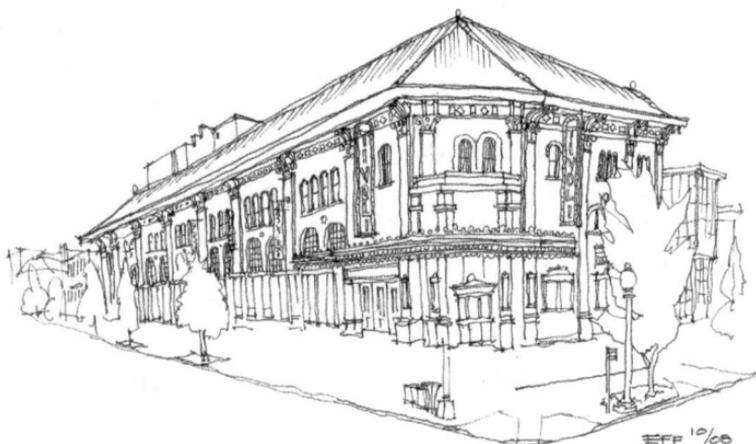

Tivoli Theatre. *By Edward F. Fogle.*

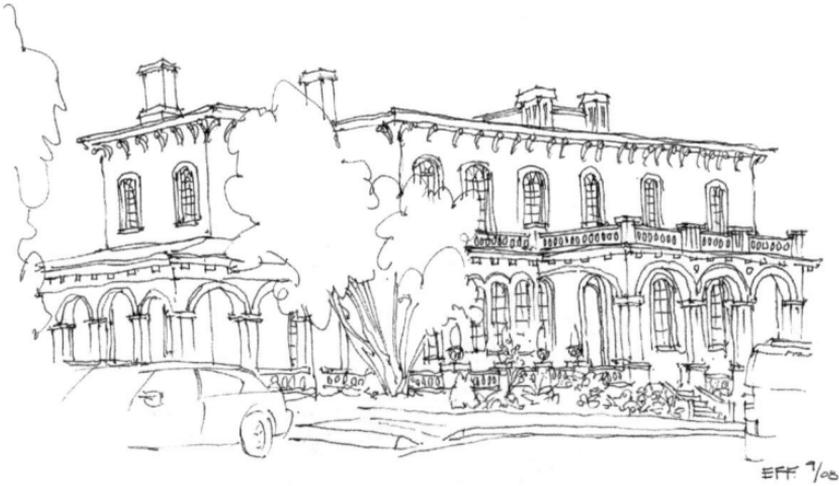

EFF 7/08

Ingleside. *By Edward F. Fogle.*

2. INGLESIDE
(1818 NEWTON STREET, NW)

Ingleside, built in the 1850s, was described as "A Southern Villa —Romanesque Style." Historically and socially, the 140-acre estate was the most important landmark in Mt. Pleasant. Thomas U. Walter, architect of the Capitol, designed Ingleside and claimed that "[it] best represented his most important work." Constructed of brick and covered with stucco, Ingleside was "two stories high with a tower, extensive porches, a conservatory, 18 rooms, [and] 3 bathrooms." General Hiram Walbridge purchased Ingleside as his country estate in 1854. A successful New York merchant, Walbridge was a brigadier general and a one-term member of Congress. In the 1890s, his heirs sold Ingleside and the property was subdivided for development. Frank B. Noyes, the editor of the *Evening Star* newspaper, purchased the house and reoriented the home's entrance to face the street. In 1911, Ingleside was acquired by the Presbyterian Home, and in 1961 it was bought by Stoddard Baptist Home, founded in 1896, originally as a retirement home for African American Baptist ministers and their wives.

119

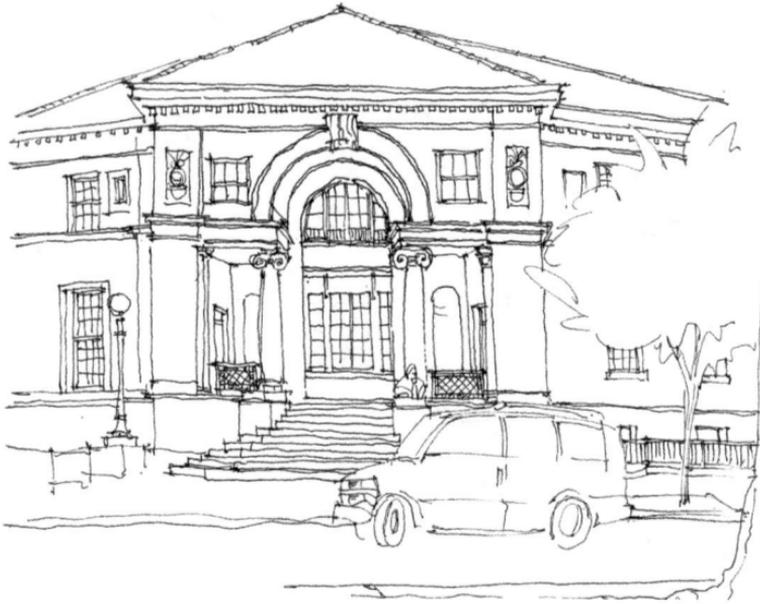

Mt. Pleasant Library. *By Edward F. Fogle.*

3. Mt. Pleasant Library
(16ᵗʰ Street at Lamont Street, NW)

Established in 1924, the Mt. Pleasant Library was the third public library built in Washington, funded by a gift of $200,000 from the Carnegie Foundation. The library was designed to look more like an executive club, to fit in with the handsome 16th Street mansions. The interior featured heavy drapes and over-stuffed armchairs placed near the fireplaces. The special feature was the children's library, which had its own outside entrance. The fireplaces were decorated with tiles depicting characters from famous fairy tales. In the reading alcoves were delightful "Animal Circus" murals, painted by a local artist, Aurelius Battaglia, and funded by President Franklin Roosevelt's Public Works of Art Program. Battaglia later moved to California to work for the Walt Disney Studios, assisting in the animation of the movie cartoons *Dumbo* and *Pinocchio.*

4. MEXICAN CULTURAL INSTITUTE
(2829 16ᵀᴴ STREET, NW)

Franklin MacVeagh gave up a career as a lawyer to become a wholesale grocer in Chicago and made a fortune. In 1909, he was appointed secretary of the treasury and moved to Washington, renting a home on Meridian Hill. MacVeagh watched with fascination as a new house was being constructed across from where he lived. When it was completed, he visited the house with his wife, expressing admiration and extending compliments to whoever the new owner might be. His wife gave him the keys to the house, saying, "Congratulate yourself." She had built it as a Christmas present for him. A few years later, Mrs. MacVeagh died and her husband moved out. In 1921, he sold the furnished house to the Mexican government, with the stipulation that it remain unchanged while he was still alive. The promise was honored, and several of the twenty-six rooms still look fundamentally the same, including the music room, which has original fresco decorations and a pipe

Mexican Cultural Institute. *By Edward F. Fogle.*

organ. When MacVeagh died in 1934, a young Mexican artist was commissioned to paint a series of colorful murals depicting scenes from Mexico's history on the staircase walls. By 1990, the embassy staff had relocated, and the Mexican Cultural Institute was established in the house as a permanent center to showcase Mexican creativity in the arts, science and culture.

5. Three Churches
(16ᵗʰ Street at Columbia Road, NW)

"The Avenue of Churches" is a nickname for 16th Street, where dozens of religious structures have been erected. On one of the

Three Churches on Meridian Hill. *By Edward F. Fogle.*

122

highest elevations stands a triad of churches: National Memorial Baptist Church, All Soul's Unitarian Church and the former Mormon "Washington Chapel."

"The Northern and Southern Baptist Conventions decided to unite in the building of a national memorial to religious liberty." In 1924, Immanuel Baptist Church was dedicated for that purpose. The massive, limestone structure, with its Baroque tower, columns and spire, also serves as a memorial to Rhode Island's founder, Roger Williams, a great defender of religious freedom. The church was later renamed National Memorial Baptist Church.

The erection of the first Mormon church in Washington was met with great controversy and opposition. In 1933, Mormonism was generally disapproved of and distrusted. Built on a prominent location, the stunning church structure is faced with bird's-eye marble quarried from a Utah mountaintop. The building was purchased in 1977 by Reverend Sun Myung Moon's Unification Church, which is as controversial today as Mormonism was in 1920.

Saint Martin's of the Field Church in London served as the architectural inspiration for the 1924 design of All Soul's Unitarian Church. Unitarianism first came to Washington in 1822 and attracted such powerful supporters as John Quincy Adams, Frederick Douglass and, in the twentieth century, President William Howard Taft, whose 1930 funeral service was held at All Soul's Unitarian Church.

NOT TO BE MISSED

6. Meridian House
(1630 Crescent Place, NW)

Quo habitat felicitas nil intret mali ("Where happiness dwells, evil will not enter") is carved over the doorway of Meridian House. In 1922, Ambassador Irwin Laughlin commissioned a Louis XV–style house, once described as "perhaps the finest house ever built in Washington." Next door is a red brick, Georgian-style house, built ten years earlier for Ambassador Henry White.

Meridian House. *Courtesy of the Star Collection, D.C. Public Library.*

John Russell Pope was the architect of both. In 1934, White's house was purchased by Eugene Meyer, owner of the *Washington Post* newspaper. Meridian International Center purchased Meridian House in 1960 in order to conduct educational and cultural programs for international visitors. In 1987, the White-Meyer House was also purchased, and together they "provide a doorway to the United States for foreigners and a window on the world for Americans."

7. Buchanan Statue
(Meridian Hill Park)

Congress chose Meridian Hill Park in 1930 as the site for a statue in honor of the fifteenth president, James Buchanan. His niece, who served as the bachelor president's first lady, left a bequest for the creation of the memorial. Buchanan was an experienced politician and diplomat, and on either side of the statue are the two memorial allegorical figures representing Law and Diplomacy. Not known as a great president, however, one critic cautiously wrote, "[Buchanan] was not deficient in talent or culture, but lacked judgment and firmness."

Two other statues dominate the park. In 1920, the Dante Alighieri statue was given on behalf of Italian Americans and dedicated on the 600th anniversary of Dante's death. Overlooking the park at the edge of the hill is an equestrian statue of Joan of

President Buchanan statue. *Courtesy of the Library of Congress HABS/HAER/HALS.*

Arc, a gift from "the women of France in 1922, to the women of the United States." The sculpture is a replica of the Joan of Arc statue at Rheims Cathedral.

8. The Potter's House
(1658 Columbia Road, NW)

One of the first, and now one of the last, remaining church-related coffeehouses in the United States is the Potter's House. Opened in the 1960, the coffeehouse is sponsored by the ecumenical Church of the Savior and staffed by volunteers. Members of the Potter's House Church are committed to serving their neighbors by "building bridges of love and trust." The unusual, open hospitality of the Potter's House creates an inviting place to read, listen to musicians and buy a handmade gift, an inexpensive lunch or a cup of coffee.

9. Grand Apartment Houses
(Ontario Road and Columbia Road, NW)

Washington's best addresses were once found in Lanier Heights (Adams Morgan). The Ontario Apartments opened in 1904 on the then semirural Ontario Road. It was Washington's first free-standing luxury apartment house meant to be seen from all sides. Approximately 60 percent of the early residents were

listed on Washington's "Elite List." The next year, the Wyoming was opened on Columbia Road, with apartments that boasted elaborate foyers, drawing rooms and three exterior exposures. In 1916, the impressive luxury Altamont apartment building opened, with spectacular upper-floor, twelve-room apartments.

10. Art on Call—Restored Fire Call Boxes
(Throughout the Neighborhoods)

On the street corners of Mt. Pleasant, and many other Washington neighborhoods, there are brightly painted and refurbished, cast-iron fire and police call boxes. Once a part of the public safety program, the city installed the first call boxes in the 1860s. Some still had working electronic components in 1995. A citywide effort was staged to save and restore some of the six hundred call boxes, converting them into artistic expressions of the neighborhood's history. In Mt. Pleasant, artist Michael Ross created bronze sculptures for the boxes, depicting the neighborhood's history from Native Americans to recent Hispanic immigrants.

Chapter 8

Mt. Vernon Square, Shaw and U Street, NW, Neighborhoods

Northern Liberties Farmer's Market was established at Mt. Vernon Square in 1846, when the neighborhood was still rural. The market's name was probably derived from a law allowing farm animals to roam at liberty beyond the northern edge of downtown. Merchants gravitated to the area, building shops near the new market that were two or three stories tall, with the business on the first floor and residence above. Although Northern Liberties was destroyed in 1872, the independent shops flourished. Newly arrived Irish, Greek, Italian and Jewish immigrants opened businesses catering to people's everyday needs, creating a bargain district.

Three Union army camps were established near Mt. Vernon Square during the Civil War, attracting former slaves seeking refuge and shelter. Because the housing in the area was less expensive, government workers began to move into the neighborhood. By the 1880s, higher-ranking government officials built stylish residences; Major John Wesley Powell lived across M Street from African American senator Blanche Kelso Bruce. The hidden alleys behind these homes were filled with coal sheds, livery stables and alley dwellings. North of Mt. Vernon Square, U Street became a center for African American–owned businesses. Several excellent "Colored" high schools were established around the area, with the best African American teachers in the country. Many teachers were Howard University (site 3) graduates, but even with their advanced degrees, professional work was often denied to them. Southern, rural African Americans also migrated to the area. The 7th Street corridor,

Map of Mt. Vernon Square, Shaw and U Street, NW, neighborhoods. *By Edward F. Fogle.*

Mt. Vernon Square, Shaw and U Street, NW

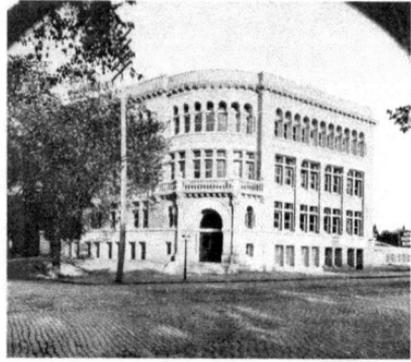

Old McKinley High School (Shaw Junior High). *Courtesy of the Washingtoniana Division, D.C. Public Library.*

between K and U Streets, NW, was lined with poolrooms, taverns, liquor stores, flophouses, storefront churches and music.

Because of Washington's segregation laws, the African American community created its own sophisticated society, "and U Street was the center of African American businesses and the heart of African American culture." Duke Ellington grew up here, playing jazz in the local clubs. African American intellectuals like Carter Woodson were attracted to the area; great musicians like Louis Armstrong performed in the local theatres. Handsome movie theatres, like the Lincoln (site 2), were opened specifically for the African American community, and many major buildings, like the Whitelaw Hotel and the 12th Street YMCA (site 4), were designed by African American architects and financed by local African American–owned banks.

After World War II, when racial restrictions on housing were outlawed, the affluent quickly moved away and the neighborhood deteriorated. In the 1960s, local churches led an urban renewal movement. The neighborhood was redefined by boundaries based on the Shaw Junior High School district. The school was named for a white officer, Robert Gould Shaw, who led African American troops in the Civil War. Before urban renewal could take hold, the 1968 riots devastated much of the area. Century-old buildings and homes were burned and looted; most businesses never reopened. Dozens of area churches, like Immaculate Conception Church (site 10), tried to help rebuild the community, but thirty years passed before positive change came to Shaw. In the 1990s, fancy loft apartments were built, row houses were restored and trendy new shops, restaurants and clubs opened for business. The old "Black Broadway" has now become "the New U."

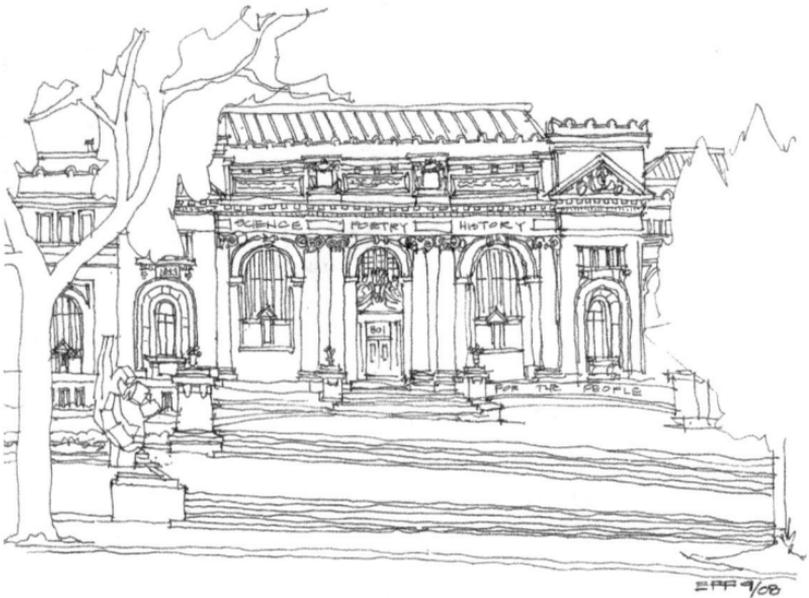

Carnegie Library. *By Edward F. Fogle.*

1. CARNEGIE LIBRARY
(8ᵀᴴ STREET AT MASSACHUSETTS AVENUE, NW)

"The little marble palace," Washington's first monumental Beaux Arts–style building, opened in 1903 as the city's first free public library. Andrew Carnegie generously funded it, and Congress chose the site on Mt. Vernon Square because it "would add dignity and beauty to a portion of the city where ornamentation is somewhat lacking." Built in a racially and ethnically mixed neighborhood, everyone was welcome to use the library. Charles Drew, the famed African American surgeon, and his brother remembered that if their mother wanted to punish them, she would take away their library cards. The library's collection moved in 1972 to a modern building, and the old library building languished until 1998, when the Historical Society of Washington purchased, renovated and reopened it in 2003 as the City Museum. Unfortunately, just eighteen months later it closed, struggling from the debt incurred in renovation. The

Historical Society's Research Library remained open, and some of the interior space was leased. The Washington Historical Society continues reaching out to people through an insightful series of free exbibits, lectures, performances, concerts and tours as it takes to heart the lofty inscriptions at the library's entrance: "A University of the People...Dedicated to Diffusion of Knowledge—Science, Poetry, History."

2. Lincoln Theatre
(1215 U Street, NW)

A classy first-run movie house exclusively for African Americans, the Lincoln Theatre, opened in 1921. Movie mogul Harry Crandall, who owned eighteen movie houses in Washington, built the Lincoln, but he placed it under African American management. A large ballroom, called the Lincoln Colonnade, was built behind the theatre. In the 1920s and 1930s, the ballroom, accessed through a

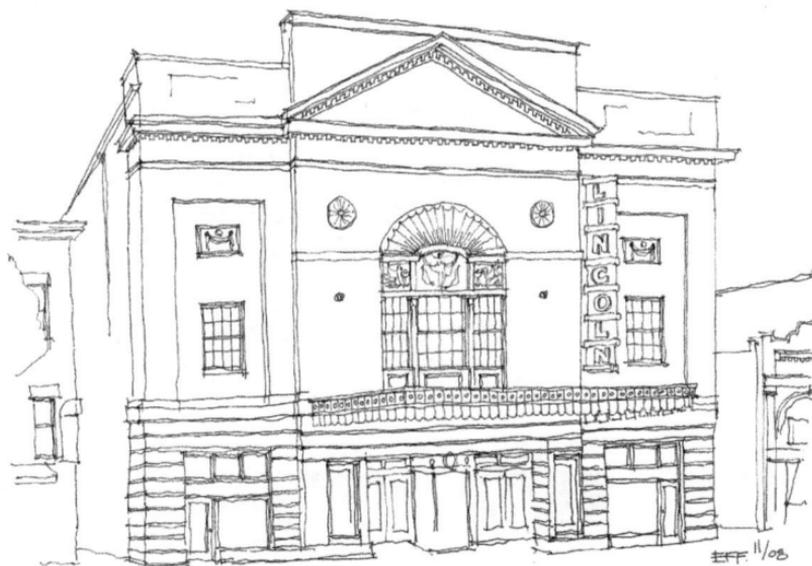

Lincoln Theatre. *By Edward F. Fogle.*

131

tunnel, was the most popular nightspot on U Street, hosting stars like native son Duke Ellington and Lena Horn. Integration caused the decline of the neighborhood because those who could afford to leave left. The colonnade was demolished and the Lincoln Theatre, affected by the 1968 riots, deteriorated and finally closed in 1982. D.C.'s government assumed ownership of the Lincoln from a bankrupt developer in 1991 and restored the original chandeliers, decorative plasterwork and the wallpaper pattern of exotic birds and flowers. The 1,240-seat Lincoln Theatre reopened in 1994 as a world-class arts and entertainment center—the "Shining Star of Washington's Black Broadway" is back.

3. GENERAL O.O. HOWARD HOME
(HOWARD UNIVERSITY)

A Second Empire–style brick home, with its mansard-roof tower, once dominated the hill at Howard University. This architectural

General O.O. Howard Home. *By Edward F. Fogle.*

gem is the only remaining original university structure on campus. It was built in 1869 as the home of the founder of the university, General Oliver Otis Howard, the university's third president. A distinguished Civil War veteran, General Howard, who lost an arm in the war, was hailed as the last surviving Civil War Union officer when he died in 1909. The First Congregationalist Church of Washington proposed the establishment of an "institution for the training of [colored] preachers" in 1866. General Howard and Dr. C.B. Boynton, the university's first president, were members of this unique integrated congregation. The university was named in honor of General Howard because of his involvement in its creation and his assistance in its funding through the Freedman's Bureau, which he headed. Howard University is one of the nation's oldest traditionally African American colleges. The list of distinguished graduates includes Supreme Court justice Thurgood Marshall and Pulitzer Prize–winning novelist Toni Morrison. General Howard's former residence has served as the Music Conservatory and home to the administrative offices. The building was renovated and given a new lease on life in 1994, when it became the headquarters for the university's Alumni Association.

4. ANTHONY BOWEN—12TH STREET YMCA
(1816 12TH STREET, NW)

Anthony Bowen, a respected educator, religious leader and government clerk, was born a slave. In 1853, he established the first YMCA for "colored men and boys" in Washington. In 1912, the YMCA moved into its own building, paid for by Washington's African American community, which received matching contributions from John D. Rockefeller and Julius Rosenwald. The 12th Street YMCA was designed by an African American architect and built by African American workers, containing seventy-two rooms and a swimming pool. "The fraternal spirit existing between the Y and the local ministry is happily shown in the use by a number of the churches of the great swimming pool for baptismal purposes." Washington's

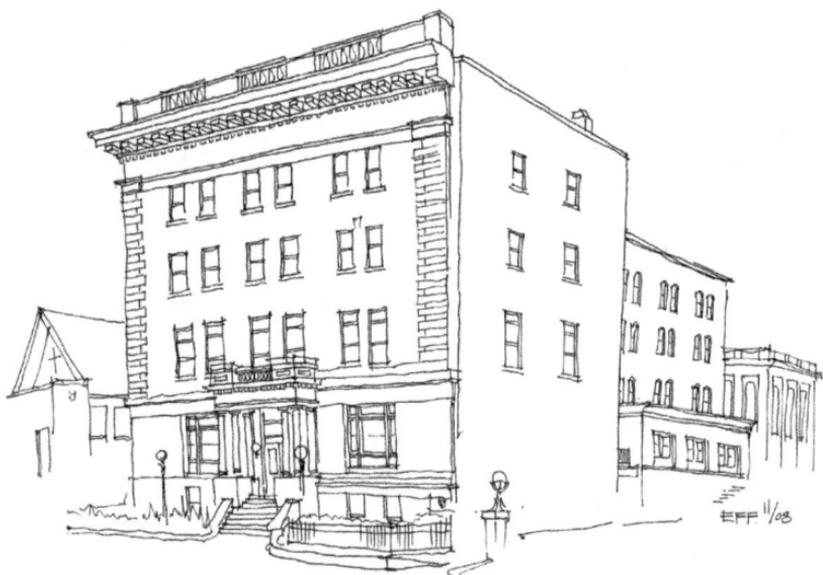

Anthony Bowen—12th Street YMCA. *By Edward F. Fogle.*

"colored" YMCA became a model for the nation; twenty-six others were built with funding assistance from Julius Rosenwald. By the 1960s, however, the building had deteriorated and it was closed in 1982. After being declared a historic landmark, the old YMCA was restored and now houses the Thurgood Marshall Center for Service and Heritage. One tiny room has been renovated to its early twentieth-century appearance as a monument to what used to be.

5. AFRICAN AMERICAN CIVIL WAR MEMORIAL
(10TH STREET AND U STREET, NW)

Sculptor Ed Hamilton named the African American Civil War Memorial *The Spirit of Freedom.* His inspiration came from the Ninety-first Psalm: "He shall cover thee with his feather and under his wings shalt thou trust." Floating above the bronze statues of soldiers and sailors is a winged protective figure inspired by the psalm. Enfolded in the wings behind the statues is a family scene

of an emotional farewell. The memorial was dedicated on the 135th anniversary of the assault on Fort Wagner in Charleston, South Carolina, in which 1,000 African American troops of the Fifty-fourth Massachusetts Regiment were led by a white officer, Robert Gould Shaw. African Americans, both freedmen and slaves, volunteered for service and made up 10 percent of the Union army by the end of the war. Inscribed on the memorial wall are names of 206,000 African American Union soldiers and sailors and 7,000 white officers who served together in 166 U.S. Colored Troop regiments. Adjacent to the memorial is the Prince Hall Masonic Lodge, designed in 1922 by Albert I. Cassell, a prominent African American architect. The Grand Lodge was founded in 1825 by ten African Americans and named in honor of Prince Hall, a Revolutionary War veteran and the first Freemason of African descent.

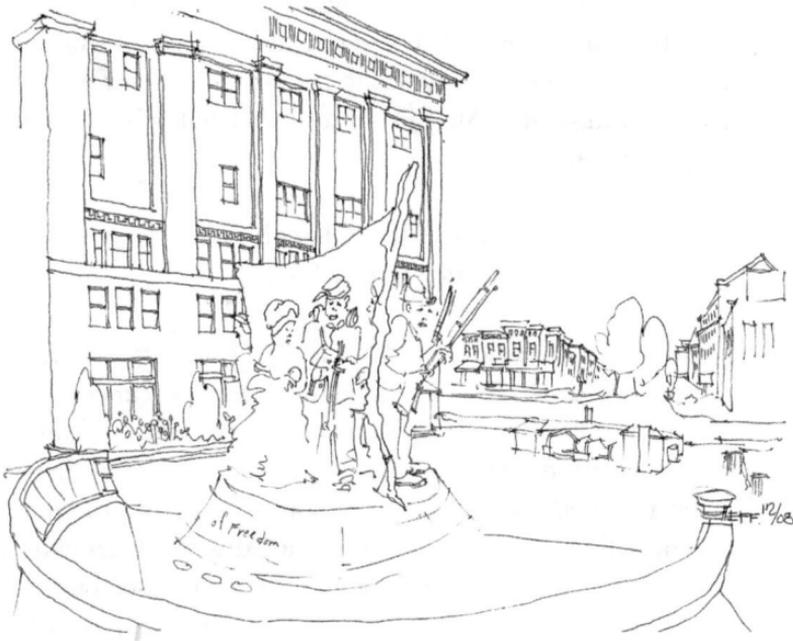

African American Civil War Memorial. *By Edward F. Fogle.*

Not to Be Missed

6. True Reformer Building
(1200 U Street, NW)

"The True Reformers led the way for U Street to become a main street for black Washingtonians," stated a local historian. The United Order of True Reformers, a Richmond-based fraternal benevolent society catering to African Americans, built its headquarters on U Street in 1903. The building contained centers for vocational training, a drill room used by Washington's Black National Guard and entertainment halls where Duke Ellington's first band preformed. In 1917, when the Knights of Pythias

True Reformer Building.
Courtesy of the Library of Congress HABS/HAER/HALS.

purchased the building as their temple, the two-thousand-seat auditorium became a popular dance hall and, later, a gymnasium for the Metropolitan Police Boys Club #2. The recently renovated building now houses the African American Civil War Museum and Visitors Center.

7. Whitelaw Hotel
(1839 13th Street, NW)

The city's only first-class hotel and apartment building for African Americans opened in 1919. The Whitelaw Hotel was named for the African American who designed it, John Whitelaw Lewis, and featured twenty-one hotel rooms and twenty-seven apartments, an elegant lobby under a stained-glass ceiling, a banquet-size dining room and a magnificent ballroom. Lewis sold shares to Africans Americans to raise money to build the hotel, explaining, "They can see buildings towering skyward and say to the world, this is what we have gotten out of prosperity." Referred to as "the Embassy" by such guests as Joe Louis, George Washington Carver and Louis Armstrong, the Whitelaw

hosted many formal dances and debutante balls. When the neighborhood declined by the 1960s, the hotel was abandoned. In 1991, the old hotel was restored as an apartment building for middle- and lower-income residents and as a community resource for public events.

Whitelaw Hotel. *Courtesy of the Library of Congress HABS/HAER/HALS.*.

8. Carter Woodson House
(1538 9th Street, NW)

The Association for the Study of Negro Life and History, founded in 1915, was the heart and soul of Carter Woodson's life's work. Wishing to convince the world of the importance of understanding the culture, contributions and origins of African Americans, he also founded the *Journal of Negro History* and established Negro History Week in 1926. The son of former slaves, Woodson became the second African American to receive a doctorate from Harvard University. Woodson's residence, used by the association until 1971, fell into disrepair. In 2006, the National Park Service purchased it, but funding for its restoration has not yet been forthcoming.

9. O Street Market
(7th Street at O Street, NW)

A new farmer's market, called Northern Market, opened in 1888, four blocks north of Mt. Vernon Square. Most of the first vendors were German immigrants, but over the years the neighborhood changed and by the 1960s most vendors were African Americans. The old market was damaged in the 1968 riots and closed. In the 1980s, it was partly restored, but a heavy wet snow caused the roof to collapse in 2003. Plans currently exist to incorporate the remaining exterior walls into a new neighborhood supermarket.

10. Three Churches
(6th and M, 7th and N, and 9th and P Streets, NW)

Bishop "Sweet Daddy" Charles Manuel Grace established the United House of Prayer for All People in Washington in 1926. "Sweet Daddy" was a showman, known for his flamboyant appearance, tricolor painted fingernails and long, flowing hair. He once baptized 208 converts in the middle of M Street, using water provided by special fire company equipment. He built a three-million-member empire and owned prime real estate across the country and a fleet of automobiles. When he died, he was buried in a glass coffin and his eulogy was given in his own voice, prerecorded. Following "Sweet Daddy" Grace was Bishop Walter "Sweet Daddy" McCullough, who built the new church known as "God's White House." Bishop S.C. "Sweet Daddy" Madison followed "Sweet Daddy" McCullough. Madison passed away in 2008, but as one member said, "We have a sense of pride that regardless of who becomes the next bishop, the House of Prayer will continue to grow."

Immaculate Conception Catholic Church was a mission church of Washington's oldest Catholic church, St. Patrick's. Associated with the church for nearly one hundred years was Immaculate Conception School for boys, now an elementary school, and Immaculate Academy for Girls, which was used until 1954. The congregation was established in 1864 and the impressive, red brick, Gothic church was built ten years later. In 1900, local-born actress Helen Hayes was baptized at Immaculate Conception Church, and for forty years the church broadcasted the *Washington Catholic Hour* on the local WOL radio station.

Before the Civil War battle at Fredericksburg, Virginia, any African American residents who wanted to evacuate were offered free transport and protection, and three hundred members of Shiloh's congregation came to Washington. After meeting in various locations, they purchased a church in 1924, which suffered a fire the next year. Another devastating fire in 1991 forced the congregation to relocate to its Family Life Center, a multiuse facility with a gymnasium, a restaurant and bowling alleys. In 1998, a new church was dedicated with a sanctuary ceiling fifty-two-feet high, a large stage, dangling microphones and bright stage lighting. "Shiloh has been an anchor in the District, and this new building shows that we are here to stay," commented one member at the dedication.

Cleveland Park and Woodley Park Neighborhoods

I t was a quiet home for a gentleman of moderate means and refined taste…on a hill…looking upon nothing but beauty and breathing nothing but health," wrote George Forest Green about the fieldstone house named Forest Hills that he built in 1869 on inherited land. Green was the grandson of Uriah Forest, who originally purchased, in the eighteenth century, 1,282 acres of productive farmland above Georgetown, where he built for his wife and family a farmhouse named Rosedale (site 2). President Grover Cleveland bought Forest Hills along with 27 surrounding acres in 1885 on the eve of his marriage, and it became "the summer White House." He remodeled it into a fancy, turreted Victorian estate and called it Oak View, or sometimes Red Top. His investment for the property and improvements was $31,500. Five years later, he sold it for $140,000 to developers, who subdivided the property and named the new neighborhood in honor of the former president: Cleveland Park.

Several country estates were built in the area and still exist. Philip Barton Key, uncle of the author of "The Star-Spangled Banner," built Woodley Mansion in 1800; it now belongs to the Maret School. Major Charles Nourse built an estate at the same time named the Highlands, which now belongs to Sidwell Friends School. In the 1880s, Gardiner Greene Hubbard, whose son-in-law was Alexander Graham Bell, purchased fifty acres and built a Colonial Revival country home named Twin Oaks, which today

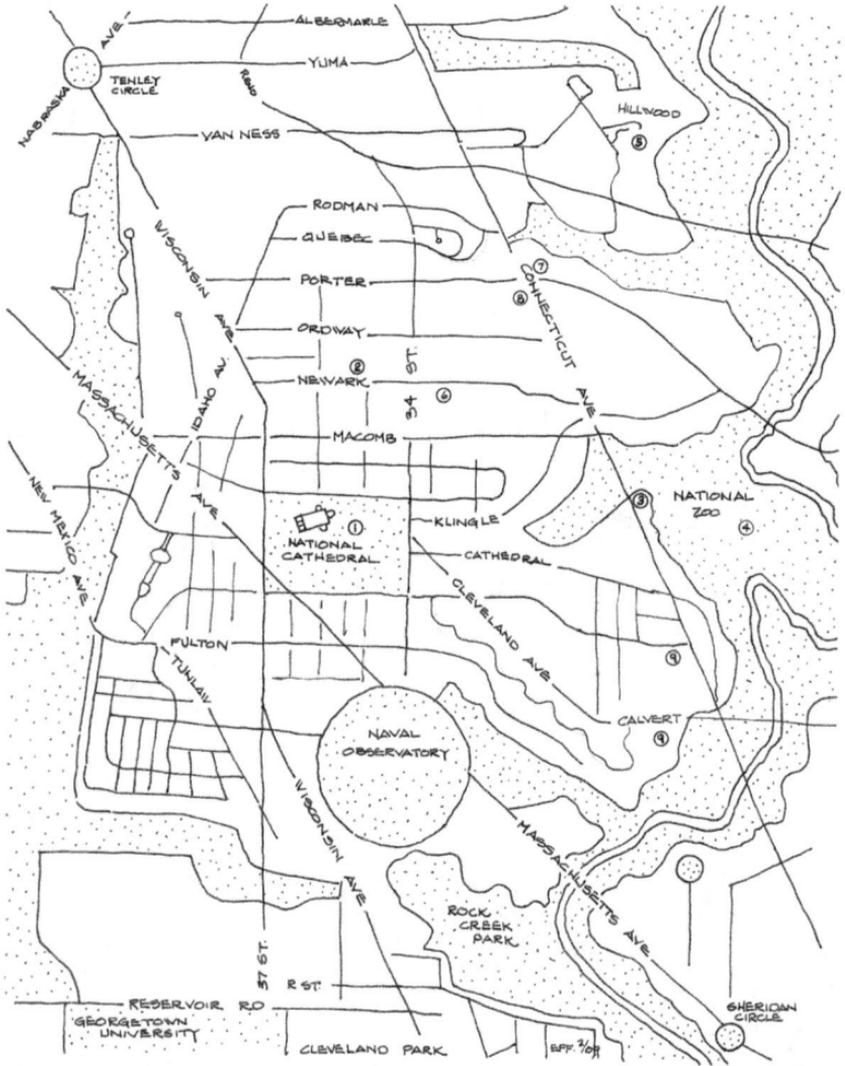

Map of Cleveland Park and Woodley Park neighborhoods. *By Edward F. Fogle.*

Cleveland Park and Woodley Park Neighborhoods

Woodley Mansion.
Courtesy of the
Washingtoniana Division,
D.C. Public Library.

is the only remaining intact summer country estate in Cleveland Park. It is owned today by Taiwan. In 1912, Tregaron was built as a year-round country estate on twenty acres of the original Twin Oaks property. In the 1940s, it was sold to Ambassador Joseph Davis and his wife, Marjorie Merriweather Post, and today houses the International School.

In 1895, development began in earnest in Cleveland Park. Streetcar service along Wisconsin Avenue made the area easily accessible. The original developers of Cleveland Park were Thomas Waggeman, the financier, and John Sherman, who handled the design, construction and sale of the unique individual homes with fanciful features like turrets, gables and wraparound porches. Community amenities were part of the plan, including a streetcar waiting station, stables for the residents' horses and a Chemical Engine (Fire) Company. Wonderful attractions surrounded the neighborhood, including Rock Creek Park, the National Zoo (site 4) and the new Naval Observatory. In 1907, construction began on the Washington National Cathedral (site 1). To the south of the cathedral, Thomas Waggeman developed another neighborhood, Woodley Park, named for Woodley Mansion. Known for its developer-built houses, the streets are lined with handsome single-family homes, elegant duplex houses and English village–style row houses designed by Harry Wardman. The luxury apartment building Wardman Tower (site 9) was built by Wardman in 1929. Waggeman's son, Clark, designed several buildings along Connecticut Avenue, including

the town house displaying a Marilyn Monroe mural painted on its exposed south side.

The city's first zoning law, enacted in the 1920s, restricted the height, area and use of buildings. Connecticut Avenue was designated as a mixed-use area and immediately, handsome, stylish apartment buildings were erected. The city's first Park and Shop (site 7) shopping complex with off-street parking opened in 1930. An Art Deco movie house was built in 1936, which today is the only surviving large-screen movie theatre in Washington. The neighborhood is so loved by its residents that comedian Mark Russell once joked, "The only time anyone moves out is when they die, go Chapter 11, or both."

1. WASHINGTON NATIONAL CATHEDRAL
(MASSACHUSETTS AVENUE AT WISCONSIN AVENUE, NW)

The idea of building a cathedral in Washington was as old as the city itself. President Washington supported the proposal of a church for national purposes, to be equally open to all. One hundred years later, Congress granted the charter to the Protestant Episcopal Cathedral Church of St. Peter and St. Paul. Funds were raised privately, architects were chosen, plans were drawn and the ground was broken in 1907 for what would become the sixth largest cathedral in the world. By 1912, the first services were held in the below-ground Bethlehem Chapel. This chapel has been used by Russian Orthodox, Polish Catholic, Jewish and other groups until their own churches or synagogues could be built. A few notable individuals are buried in the cathedral, including Woodrow Wilson and Helen Keller, and religious leaders of all faiths have been invited to speak from the pulpit, such as Martin Luther King and the Dalai Lama.

Symbolism is the soul of Gothic architecture. More than one hundred functional gargoyles that spurt rainwater from their gaping mouths give character to the cathedral. Beautifying the cathedral's interior are twelve hundred pieces of needlework, magnificent wood carvings and outstanding wrought-iron work by the master blacksmith Samuel Yellin, known as the devil

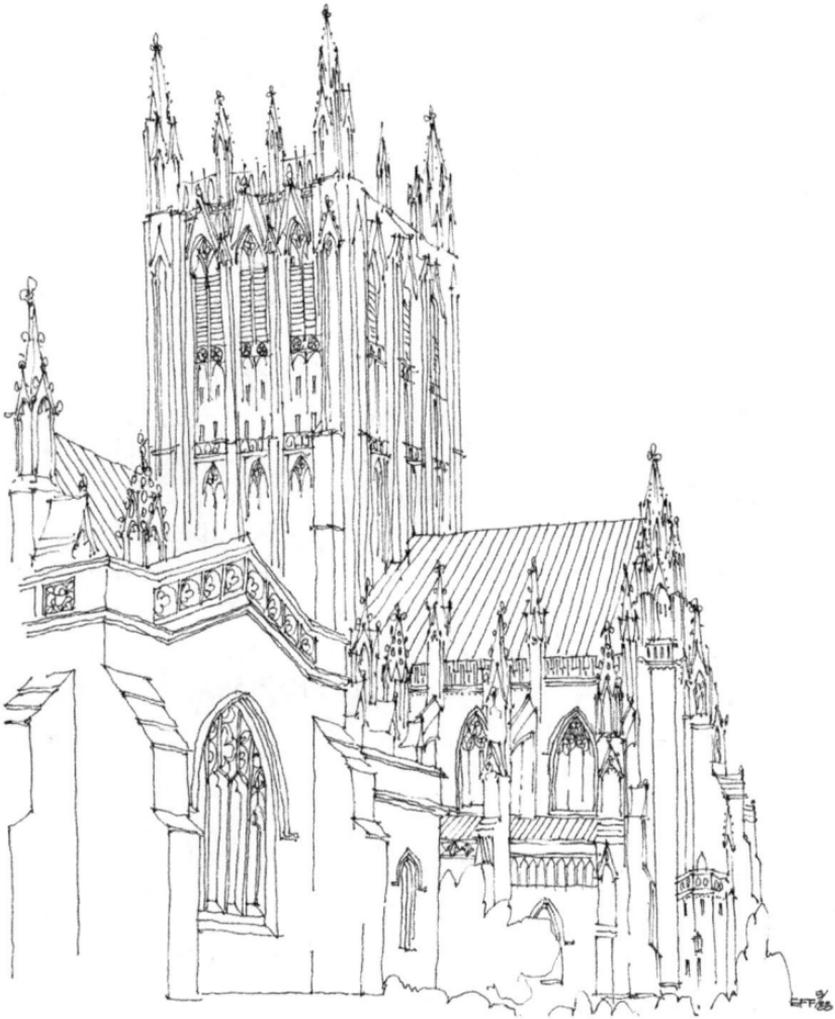

Washington National Cathedral. *By Edward F. Fogle.*

with a hammer. The queen of cathedral art is stained glass, and more than two hundred stained-glass windows adorn the cathedral, including one window featuring a moon rock brought back to earth by the Apollo 11 astronauts. The brilliant colored light filtering onto the carved limestone walls prompted mason foreman Joe Alonzo to declare, "This building is one big work of art."

2. Rosedale
(3501 Newark Street, NW)

"America's real monuments are the fine old homes that tell the history of our country." Rosedale is just such a place, built by Uriah Forest in 1793 as a respite for his wife and his family. He constructed the wooden-frame farmhouse, "an humble stretched-out barracks," and attached it to an existing 1730s-era stone cottage, "the box." Uriah Forest served as an aide-de-camp to Washington and as mayor of Georgetown; he was one of the founders of the Federal City, a successful merchant and an elected member to the Third Congress from the District of Columbia, a rare status. His wife, Rebecca, was a "woman of modest and unassuming tastes...who preferred her garden to her house and her family's welfare over social status." Reversals of fortune nearly caused Uriah Forest to lose Rosedale, but Rebecca's brother-in-law, Philip Barton Key, accepted the mortgage and later forgave the debt. The house was occupied by the family for 124 years.

Rosedale. *By Edward F. Fogle.*

In 1917, the Coonley family rented Rosedale, which was in need of repair. The Coonleys rehabilitated the farmhouse, and in 1920 they purchased it. The Washington National Cathedral bought Rosedale in 1959 for the Cathedral Girls' School and surrounded it with three modern dormitories. In 1977, a student exchange group purchased Rosedale and made the news in 2000, when it offered the house for use by the relatives of the young Cuban refugee Elian Gonzalez. The next year a developer wanted to purchase Rosedale and subdivide the property. The neighborhood rallied to fight for preservation. In 2004, Rosedale's neighbors were successful in raising private funds to purchase and restore the house and historic terraced grounds. Rosedale is now part of a land trust, forever preserved, and looks much as it did more than two centuries ago.

3. Kennedy-Warren Apartments
(3133 Connecticut Avenue, NW)

The finest, most dramatic Art Deco apartment building in Washington is the Kennedy-Warren. Named for the builders, Edgar S. Kennedy and Monroe Warren Sr., the original project was designed to have 442 apartments, fifty hotel rooms, a grand main lobby, ballrooms and a parking garage. With the advent of the Great Depression, the owners declared bankruptcy in 1931, when only half of the building was completed. The mortgage company took over the management and added the rear wing in 1935. The building is nine stories in the front; however, it sits on a ridge overlooking Rock Creek Park and drops another six stories in the rear. Apartments ranged in size from efficiencies with Murphy beds, to luxury top-floor suites with foyers, fireplaces and windows on three sides. The Kennedy-Warren offered the first "forced-air cooling system" in Washington. Huge basement fans pulled in cool air from the park and distributed it through metal-louvered panels over each unit's door. Listed among Washington's top "best addresses," past tenants include Harry Truman and Lyndon Johnson. In 1987, the original plans for

Kennedy-Warren Apartments. *By Edward F. Fogle.*

the unbuilt south wing were discovered. Strictly adhering to
the appearance of the original structure, the wing was built in
2002. Many residents have rented in the building for decades,
and one longtime tenant noted, "When I come in the door after
work, I feel like saying 'Hi everybody, I'm home.' It's just that
kind of place."

4. NATIONAL ZOOLOGICAL PARK
(3001 CONNECTICUT AVENUE, NW)

After the Civil War, the yard behind the Smithsonian Castle
was used by taxidermists studying living specimens as models
when creating exhibits. American bison and other exotic animals
from the American frontier attracted thousands of tourists
every day. In 1889, land in Rock Creek Park was appropriated
for a Zoological Park, under the direction of the Smithsonian

Institution. Following the natural contours of the property, Frederick Law Olmsted landscaped the 166-acre zoo, which was immediately hailed as a "city of refuge" for the nation's vanishing species. The Barnum & Bailey Circus, which wintered in nearby Bailey's Crossroads, Virginia, passed along the first elephants, lions and zookeepers. In 1931, the Reptile House was erected to exhibit the largest collection of its kind in the world. The design for the unusual building was drawn from the early Italian Romanesque–style monastic buildings, enhanced with variegated red brick, stone corbels carved with the heads of reptiles and a rich, glazed, mosaic tile mural over the entry. The pandas are the zoo's most popular attraction today, but the most famous resident was Smokey the Bear, who was rescued from a New Mexico forest fire in 1950. The four-and-a-half-pound cub became a symbol to help educate Americans about the dangers of forest fires with his slogan, "Only YOU can prevent forest fires." Although he died in 1976, Smokey the Bear is still one of America's best-loved icons.

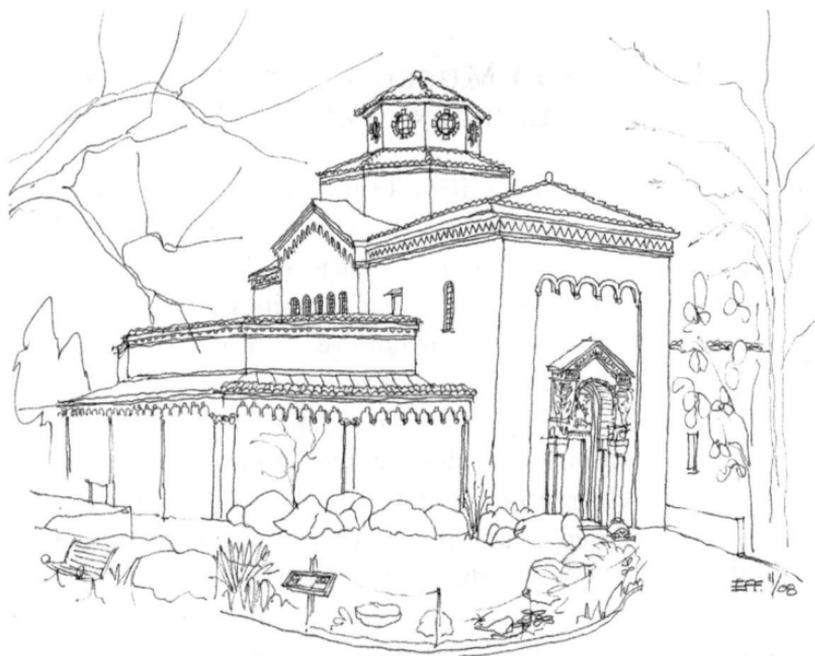

National Zoo Reptile House. *By Edward F. Fogle.*

Hillwood House Museum. *By Edward F. Fogle.*

5. HILLWOOD MUSEUM AND GARDENS
(4155 LINNEAN AVENUE, NW)

She was called "the American Empress" and her home was
affectionately referred to as "Moscow on the Potomac" or
"Washington's Little Versailles." Marjorie Merriweather Post,
an only child, inherited her father's business, Postum Cereal
Company, and built it into an empire. In the 1920s, she was
convinced that frozen foods could transform everyday life, and
she purchased Birds Eye Frozen Foods, the first of several food
company acquisitions that she merged to create the powerful
General Foods Corporation. In 1955, at the age of sixty-eight,
Mrs. Post purchased a lavish twenty-five-acre estate on Rock
Creek Park. She renovated the house, which she named Hillwood,
and filled it to overflowing with a vast decorative arts collection
of approximately six thousand items chosen from a collection
many times that size. Mrs. Post lived and entertained there for

the remainder of her life. She used her maiden name after being married and divorced four times. When she asked her lawyer why she couldn't find the right husband, he joked, "I think the reason is that you try to make them all Mr. Post." A legendary heiress, Marjorie Merriweather Post was unpretentious, kind and generous to all. She entertained royalty and newly returned Vietnam War veterans with equal style and grace. She supported the American Red Cross and the Boy Scouts; she donated jewels to the Smithsonian Institution; and to the American people, she gave her fabulous home and incomparable collection of decorative arts.

NOT TO BE MISSED

6. Cleveland Park Houses
(Newark Street, NW)

Cleveland Park was "the prettiest suburb in Washington" because developer John Sherman hired a team of well-established architects to create one-of-a-kind houses. Paul Pelz designed frame homes with verandas, porticos, towers and Palladian windows, like 3410, 3440 and 3512 Newark Street Northwest. Frederic Pyle designed homes with oval projecting porches, sloping rooflines and gracious piazzas, like 3240, 3322 and 3409 Newark Street. Between 1902 and 1909, his talented wife, Elle Bennett Sherman, introduced her own charming architectural

Cleveland Park house. *Courtesy of the Washingtoniana Division, D.C. Public Library.*

style, designing more modest-sized homes, some with unusual decorative motifs made of rope dipped in plaster, like that seen at 3121 Newark Street. Most of the neighborhood's development was essentially complete by the 1930s, and although Cleveland Park homes vary widely in style, from Victorian Gothic, Queen Anne, Stick, Shingle and Neocolonial to Mission and Prairie, together they serve as an architectural museum of late nineteenth-century suburban residences.

7. Park and Shop
(Connecticut Avenue and Ordway Street, NW)

A new innovative commercial amenity was introduced to the Cleveland Park neighborhood in 1931: the "Park and Shop." A block-long, L-shaped, Neocolonial brick building housing a series of connected shops to make shopping convenient, the shopping strip was focused around a "car-parking court," paying tribute to the growing importance of the automobile. The Piggly Wiggly grocery store, the area's first food mart, opened in the new Park and Shop, along with a gas station and an "automobile laundry." Setting the standard for the city's small neighborhood shopping centers with off-street parking, Park and Shop is believed to be one of the oldest strip shopping centers in the country. When developers threatened, in 1986, to replace it with a glass and steel high-rise office complex, the local residents rallied, fought and won the battle for the little shopping mall that changed the city.

Park and Shop. *Courtesy of the Library of Congress HABS/HAER/HALS.*

8. Uptown Theatre
(3432 Connecticut Avenue, NW)

Opened in 1936, the Uptown Theatre is Washington's last surviving large movie house. An Art Deco gem, the lobby walls were lined with black marble, and the doors were colored "Mexican Red" with metal zigzag designs. Remodeled in 1956 with a new screen and sound system, it was remodeled again five years later, reducing the seating from 1,300 to 950 to accommodate a huge wraparound screen. The third major renovation came in 1996, with new velour seats, wallpaper, carpet and drapes. "If you want to see a movie and experience the old-fashioned ambience, if you want to take a step-back to an earlier time, go to see a movie at the Uptown."

9. Historic Hotels
(Connecticut Avenue at Calvert Street, NW)

Harry Wardman built many of the quality apartment buildings in Washington, including the city's largest hotel-apartment complex in Woodley Park. The Wardman Park Hotel offered one thousand rooms and many amenities, like a roof garden, a five-hundred-seat dining room and a Turkish bath. In 1928, Wardman added the Wardman Tower, a luxury apartment wing, containing thirty-two large apartments, with up to ten rooms each. More high-ranking government officials resided there than in any other place in Washington, and their parties were legendary. Sheraton Corporation purchased the complex in 1953 and razed the beautiful Wardman Park Hotel in 1978, replacing it with a modern, sterile, impersonal hotel. Fortunately, Wardman Tower was saved, preserving a little of the history of the famous residents who once called it home.

In 1930, the Shoreham Hotel was opened across from the Wardman Park Hotel. Overlooking Rock Creek Park, the hotel offered both overnight accommodations and residential suites that were up to twenty-six hundred square feet. The hotel had an indoor ice rink and a furniture factory in the basement—the only

151

one in the country—that provided custom-built furniture for the lobby and the rooms. The world's most renowned comedians, musicians and actors performed in the Shoreham's famed Blue Room and Marquee Lounge: "In naming those who lived, stayed, and performed, wined, dined and 'made history at the Shoreham,' it's easier to name who hasn't."

Notes

CHAPTER 1

1. "Corcoran Gallery of Arts," see the *Washington Post*, February 1, 1970.
2. "Octagon House," see McCue, *The Octagon*, 71.
3. "St. John's Church," see Green, *Church on Lafayette Square*, 7, 19.
4. "Willard's Hotel," see Eskew, *Willard's of Washington*, 127.
5. "Eisenhower Executive Office Building," see "Old Executive Office Building: A Brief History," *pEOPle Executive* (October 1978).

CHAPTER 2

1. Introduction, see Kite, *Historical Documents*, 55.
2. "Brumidi House," see Fry, *Fry's Patriotic Story*, 39, 41.
3. "Not to Be Missed—Lincoln Park," see Federal Writer's Project, *Washington City and Capital*, 614.

CHAPTER 3

1. "St. John's Church Georgetown," see Ecker, *Portrait of Old Georgetown*, 166.
2. "Bodisco House," see Mackall, *Early Days of Washington*, 312.
3. "Dumbarton Oaks," see Federal Writer's Project, *Washington City and Capital*, 744.

NOTES

CHAPTER 4

1. Introduction, see the *Washington Post*, October 10, 1931.
2. "Sixth and I Synagogue," see the *Washington Post*, September 9, 2008.
3. "Pension Building," see Lyons, *Handbook to the Pension Building*, 13; *Museum Washington* (August/September 1985); and Applewhite, *Washington Itself*, 216.
4. "Masonic Lodge," see U.S. Geological Survey, "Building Stones in the Capital," http://pubs.usgs.gov/gip/stones/index.html.
5. "Not to Be Missed," see *Washington Star*, December 16, 1867; and Joint Committee on Landmarks of the National Capital, August 3, 1979.

CHAPTER 5

1. Introduction, see Froncek, *City of Washington*, 47, 250.
2. "Textile Museum," see the *Washington Post*, March 26, 2006.
3. "Anderson House," see the *Washington Post*, December 18, 1997.
4. "Woodrow Wilson House," see Wilson, *My Memoir*, 312.
5. "Phillips Collection," see Applewhite, *Washington Itself*, 55; *Washingtonian* (October 1989): 154; and the *Washington Post*, June 15, 1986.
6. "The Lindens," see Eberlein, *Historic Houses*, 432.
7. "Townsend Mansion," see Commission of Fine Arts, *Massachusetts Avenue Architecture*, 220; and *Cosmos Club*.
8. "Walsh-McLean Mansion," see McLean, *Father Struck It Rich*, 111.
9. "Spanish Steps," see Applewhite, *Washington Itself*, 50.

CHAPTER 6

1. Introduction, see Robert H. Harkness's article in *Columbia Historical Society Records*, 218.
2. "DAR," see Applewhite, *Washington Itself*, 112; and Lonnelle Aikmen's article in *National Geographic Magazine* (November 1951).
3. "St. Mary's," see Applewhite, *Washington Itself*, 282.
4. "Not to Be Missed," see Miller, *Great Houses of Washington*, 199; and Gill, *John F. Kennedy Center*, 3.

NOTES

CHAPTER 7

1. "Ingleside," see "Application for Landmarks of the National Capital," February 13, 1979; and the *Evening Star*, May 17, 1929.
2. "Three Churches," see Federal Writer's Project, *Washington City and Capital*, 484; and Staples, *Washington Unitarianism*, 74.

CHAPTER 8

1. "General Howard's Homes," see the *Washington Times*, May 9, 1992.
2. "Anthony Bowen—YMCA," see Fitzpatrick, *Black Washington*, 145; and Green, *Secret City*, 179.
3. "True Reformer's Hall," see Fitzpatrick, *Black Washington*, 168.
4. "Whitelaw Hotel," see the *Washington Post*, March 1, 1992.
5. "Three Churches," see the *Washington Post*, April 14, 2008; March 14, 1998.

CHAPTER 9

1. Introduction, see the *Washington Post*, April 13, 1991.
2. "Rosedale," see Mann-Kenney, *Rosedale*, cover page, 17.
3. "Kennedy-Warren," see the *Washington Post*, March 6, 1986.
4. "Hillwood," see the *Washington Post*, March 1995.
5. "Not to Be Missed," see Colbert, *Omni Shoreham Hotel*, 2005.

Bibliography

Applewhite, E.J. *Washington Itself*. New York: Alfred A. Knopf, 1981.

Beauchamp, Tanya Edwards. *The Historic District*. Washington: D.C. Historic Preservation Office, 1998.

Brocket, Anne, ed. *Woodley Park Historic District*. Washington: D.C. Historic Preservation Office, 2004.

Cherkasky, Mara. *Village in the City*. Washington: Cultural Tourism D.C., 2006.

Colbert, Judy. *Omni Shoreham Hotel: Celebrating Capital Service*. Washington, D.C.: 2005.

Columbia Historical Society Records. Vol. 18. Washington, D.C.: National Capital Press, Inc., 1915.

Commission of Fine Arts. *Massachusetts Avenue Architecture*. Vol. I. Washington, D.C.: Government Printing Office, 1973.

The Cosmos Club: A Self-Guided Tour of the Mansion. Washington, D.C.: Cosmos Club, n.d.

Eberlein, Harold Donaldson. *Historic Houses of Georgetown & Washington City*. Richmond, VA: Dietz Press, Inc., 1958.

Ecker, Grace Dunlop. *A Portrait of Old Georgetown*. Richmond, VA: Garrett & Massie, Inc., 1933.

EHT Traceries, Inc. *Foggy Bottom Historic District*. Washington: D.C. Historic Preservation Office, 2004.

Eskew, Garnett Laidlaw. *Willard's of Washington*. New York: Coward-McCann, Inc., 1950.

Federal Writer's Project. *Washington City and Capital*. Washington, D.C.: Government Printing Office, 1937.

BIBLIOGRAPHY

Fitzpatrick, Sandra. *Black Washington*. New York: Hippocrene Books, 1999. Revised edition.

Fogle, Jeanne. *Proximity to Power*. Washington, D.C.: A Tour de Force, Inc., 1999.

———. *Two Hundred Years: Stories of the Nation's Capital*. Arlington, VA: Vandamere Press, 1991.

———. *Washington, D.C.: A Pictorial Celebration*. New York: Sterling Publications, 2005.

Froncek, Thomas. *The City of Washington*. New York: Alfred A. Knopf, 1981.

Fry, Smith D. *Fry's Patriotic Story of the Capitol*. Washington, D.C.: 1912.

Gill, Brendan. *John F. Kennedy Center for the Performing Arts*. New York: Harry N. Abrams, Inc., 1981.

Goode, James M. *Best Addresses*. Washington, D.C.: Smithsonian Books, 1988.

———. *The Outdoor Sculpture of Washington, D.C.* Washington, D.C.: Smithsonian Institution Press, 1974.

Green, Constance McLaughlin. *The Church on Lafayette Square 1815–1970*. Washington, D.C.: Potomac Books, Inc., 1907.

———. *The Secret City*. Princeton, NJ: Princeton University Press, 1967.

———. *Washington Village and Capital*. Princeton, NJ: Princeton University Press, 1962.

Headley, Robert K. *Motion Picture Exhibition in Washington, D.C.* Jefferson, NC: McFarland & Co., 1999.

Kite, Elizabeth S. *Historical Documents Institut Français de Washington, Cahier III, L'Enfant and Washington 1791–1792*. Baltimore: Johns Hopkins Press, 1929.

Levy, Jane Freundel. *Midcity at the Crossroads*. Washington: Cultural Tourism D.C., 2006.

———. *Roads to Diversity*. Washington: Cultural Tourism D.C., 2005.

Lyons, Linda Brody. *A Handbook to the Pension Building*. Washington, D.C.: National Building Museum, 1989.

Mackall, S. Somervell. *Early Days of Washington*. Washington, D.C.: Neale Company, 1889. Reprint 1934.

Mann-Kenney, Louise. *Rosedale*. Washington, D.C.: 1989.

McCue, George. *The Octagon*. Washington, D.C.: American Institute of Architects, 1976.

McLean, Evelyn Walsh. *Father Struck It Rich*. Ouray, CO: Bear Creek Publishing, 1981.

Miller, Hope Ridings. *Great Houses of Washington D.C.* New York: Bramhall House, 1964.

BIBLIOGRAPHY

Mitchell, Henry. *Washington Houses of the Capital*. New York: Viking Press, 1982.

Proctor, John Clagett. *Washington Past and Present*. New York: Lewis Historical Publishing Company, Inc., 1930.

Smith, Kathryn Schneider. *Washington at Home*. Washington, D.C.: Windsor Publications, 1988.

Smith, Kathryn S. *City within a City*. Washington: D.C. Heritage Tourism Coalition, 2001.

Staples, Laurence C. *Washington Unitarianism: A Rich History*. Washington, D.C.: 1970.

Williams, Kimberly Prothro. *Capitol Hill Historic District*. Washington, D.C.: Historic Preservation Office, 2002.

———. *Cleveland Park Historic District*. Washington, D.C.: Historic Preservation Office, 2001.

Wilson, Edith Bolling. *My Memoir*. Indianapolis: Bobbs-Merrill Company, 1938.

Visit us at
www.historypress.net